AUGUSTA AND SUMMERVILLE

IMAGES
of America

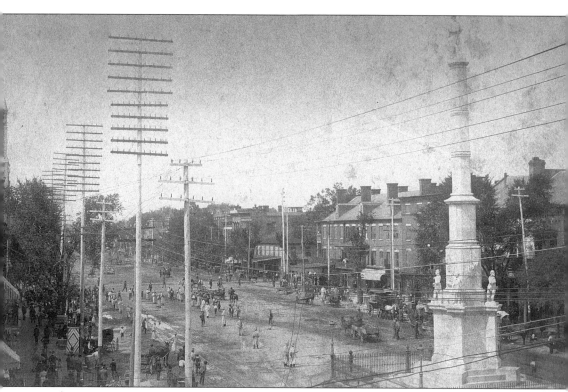

This image from the Augusta Art Gallery depicts the appearance of Broad Street (c. 1888) at the beginning of some important event. Men in topcoats and top hats are lining up in the street and a crowd is beginning to gather. Note the telegraph, telephone, and electric lines cluttering the view. Telephones had been introduced in 1879 and electricity in 1884. The telegraph had been introduced much earlier. There were about 125 telephone subscribers when this photograph was taken. The trolley system was not yet electrified, as that did not happen until May 30, 1890.

AUGUSTA AND SUMMERVILLE

Joseph M. Lee III

Copyright © 2000 by Joseph M. Lee III.
ISBN 0-7385-0616-8

Published by Arcadia Publishing,
an imprint of Tempus Publishing, Inc.
2 Cumberland Street
Charleston, SC 29401

Printed in Great Britain.

Library of Congress Catalog Card Number: 00-106710

For all general information contact Arcadia Publishing at:
Telephone 843-853-2070
Fax 843-853-0044
E-Mail sales@arcadiapublishing.com

For customer service and orders:
Toll-Free 1-888-313-2665

Visit us on the internet at http://www.arcadiapublishing.com

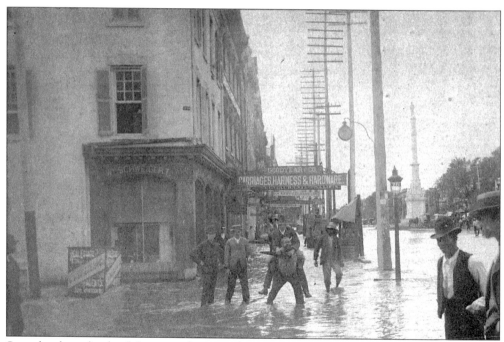

Some hardy souls who did not mind getting their feet wet pose for the photographer during the flood of September 10-11, 1888, at the southwest corner of Broad Street and McIntosh Street (7th). William Schweigert's Jewelry store is on the corner at 702 Broad. You could earn some pocket change by ferrying people across flooded areas for a fee. Schweigert succeeded F.A. Brahe at this location around 1886 and continued in the jewelry business into the 1900s. Mr. Schweigert later became president of the Union Savings Bank and sold the business to his son-in-law, Carter Burdell. The Augusta Photo Company took the photograph. Its studio was on the top floor of 702 Broad Street.

Contents

Introduction 7

1. Broad and Greene Streets 9

2. Monuments, Parks, and Cemeteries 31

3. Around Town 51

4. Water and Steam 89

5. African-American Life 101

6. Summerville and the Augusta Arsenal 111

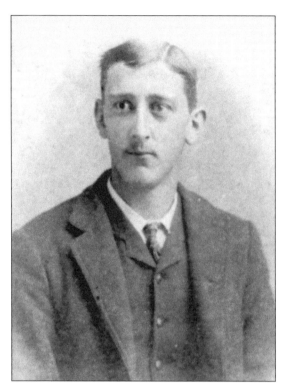

Ralph Inglsby Rogers (c. 1885) was the proprietor of Ralph I. Rogers & Brothers, Contractors & Builders, in the late 1880s. Their specialty was repairing, job work, and carpentry. Their office was in a store at 1138 Greene Street on the southeast corner at Marbury Street (12th). (Photographer: M.L. Cormany; courtesy Jean A. Getchall.)

John Rountree Rogers (c. 1875) was the second brother working for Ralph I. Rogers & Brothers. The third brother, not pictured, was Dudley Rogers. He later moved to Sardis, located in Burke County, GA. John and Ralph later worked as carpenters at the Augusta Arsenal. (Photographers: Pelot & Cole.)

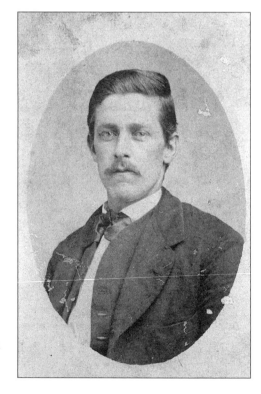

INTRODUCTION

This volume contains information about Augusta and its environs in the last half of the 19th century. Augusta survived the Civil War unscathed. Its population grew from 12,000 in 1860 to over 39,000 by 1900. *Harper's Weekly* described the city in 1887 as "a typical representative of both the Old and the New South." Similar articles were published in *Frank Leslie's Illustrated Newspaper* in 1880 and 1888. In a series of articles regarding "The Industrial South" in 1887, *Harper's Weekly* touted Augusta's growth in trade, wholesale, retail, and manufacturing. Much was made of its cotton industry and the waterpower of the recently enlarged canal. The reporter was impressed by the city's wide and well laid out streets: "Its streets, notably Greene and Broad, the two most important avenues, one of residences and the other of business houses, are wide, straight, and heavily shaded by arching elms, stately oaks, and glossy-leafed magnolias. At intervals the green of the foliage is relieved by the gleaming marble of a monument, or the flash and sparkle of a fountain. There is plenty of room in Augusta, and its comfortable, heavily porticoed residences are surrounded by pleasant gardens and ample breathing spaces. Many of the homes, as well as the public buildings and educational institutions of the city, all of which occupy tree-shaded parks, are built of brick, covered with stucco, and painted white. From March until December the old-fashioned gardens are filled with flowers, and the green arches of the streets echo with bird music."

Maybe that is a little gilded in step with the times, but would it not be nice if we had pictures instead of words to see what the city really looked like. During this period a new type of photography became popular. The stereograph, or as it is commonly known, the stereo view, became the common man's window to the world. The most numerous type is a double photograph printed on a card in such a manner that when glimpsed through a stereoscope device it appears as a three-dimensional image. Augusta was fortunate to have photographers who produced stereo views, leaving us with a rare and unique visual record of the period. Tucker and Perkins (Isaac Tucker and Jabaz W. Perkins) produced the earliest known stereo pictures of Augusta and of Aiken, SC, in 1859. One of their Augusta scenes survives at the Augusta Museum of History. J.W. Perkins produced a few views of Augusta in the late 1860s. John Usher Jr. issued numerous Augusta landscapes from the early 1870s to the early 1880s. J.A. Palmer of Aiken produced many views of Aiken, Augusta, and Atlanta among other locations. Palmer also produced many scenes of African-American life in the 1870s and 1880s. J.L. Schaub, from LaGrange, GA, developed many southern views including at least 41 of Augusta, but only a few of his Augusta views have been found. M.L. Cormany produced scenes in the

mid-1880s, but only four have been found. E.T. Gerry produced a rare set of views of African-American life in Augusta in the mid-1890s. Perkins & Pelot (J.W. Perkins and A.A. Pelot) and Pelot & Cole (A.A. Pelot and James D. Cole) issued stereographic views, but they are rare and the few that have been found appear to be from the old Tucker and Perkins negatives. These stereo views form the bulk of the images in this book. The images represent the better half of the stereo view. They are not shown in stereo format (except for one example) because of technical considerations. The remaining images in the book are from the photograph collection of the Richmond County Historical Society, the Augusta Museum of History, and the author's collection of old Augusta photographs.

This pictorial history depicts all aspects of life in Augusta: Broad Street, Greene Street, the 1888 flood, major monuments, cemeteries, churches, businesses, the fire department, people, schools, the canal, cotton, African Americans, Summerville, and the Augusta Arsenal. The images included here are from the author's collection unless otherwise specified. All addresses (when known) are the ones assigned when street addresses were revised in 1880. The "*Chronicle*" refers to the *Augusta Chronicle* newspaper under all of its various names over the period. Many of the details regarding events depicted in the book were gleaned from the *Chronicle*. Other references used were *Dressed for the Photographer, Ordinary Americans & Fashion, 1840–1900* by Joan L. Severa (Kent State University Press, Kent, OH, 1995); the *Hand Book of Augusta, A Guide to the Principal Points in and About the City*, compiled by John L. Maxwell, Pleasant A. Stovall, and T.R. Gibson (Augusta, GA, 1878); *The Signers' Monument in Augusta*, Georgia Writers Project, Augusta, GA, May 24, 1937; the *History of the Augusta Fire Department*, compiled by Ben A. Peuffier (Augusta, GA, Chronicle Job Printing Company, 1895); and Augusta City Directories (1841, 1859–1900).

I would like to thank the Augusta Museum of History for its support and assistance. A special thanks goes to Scott Loehr (executive director), Paul Bright (director of exhibition and design), Gordon Blaker (director of curatorial services), and Zinnia Weise (registrar) for their interest and helpful cooperation. Thanks goes out to the Richmond County Historical Society and especially Vicki Greene (executive director) for her help and support, as well as Erick Montgomery (executive director of Historic Augusta, Inc.), for his help in identifying photographs and architectural styles. Bill Baab's friendship over the years and our mutual interest in anything historical regarding Augusta has yielded valuable information. Bill is unselfish in sharing his resources and knowledge of Augusta history to the benefit of all, and he helped me immensely by proofreading the manuscript. I want to express my appreciation to Mike Griffith, expert on antique southern photography, collector, and dealer, for his interest and helpful cooperation. Mike provided an important stereo view for the book. I also wish to thank Michael White for his assistance and cooperation in identifying photographs and for allowing me to use his research findings regarding the Confederate Powder Works.

I owe a tremendous debt of gratitude to Dr. Edward J. Cashin, former chairman of the Department of History, Political Science, and Philosophy at Augusta State University, for his notes from the *Augusta Chronicle* that were compiled when he was researching for his book *The Story of Augusta* (published in 1980). They are an indispensable reference when researching the *Chronicle*. I also owe Virginia Lee a tremendous debt for her support and help while I was working on this book. She showed a great deal of patience and understanding at my interest in this project and for that I am truly grateful.

One
Broad and Greene Streets

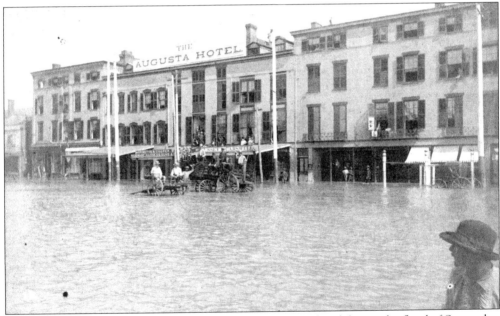

The Augusta Hotel, situated at 607 Broad Street, was inundated during the flood of September 10-11, 1888. It opened about 1851 and enjoyed a good patronage. Noted for its comfortable appointments and excellent table, it was known as the "Old Reliable." Several of the buildings or portions of the buildings that comprised the hotel are still standing. The hotel rooms were on the second and third floors while various businesses occupied the Broad Street level. It closed about 1894 but reopened as the Commercial Hotel in 1898. It remained open as a hotel under various names well into the 20th century (*Augusta Chronicle*, September 19, 1890, and May 12, 1935). (Courtesy Richmond County Historical Society.)

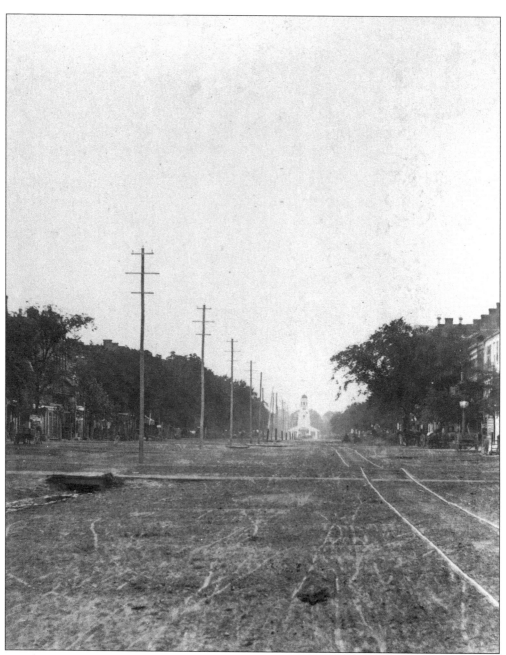

Broad Street at ground level in the early 1870s was not an inviting-looking thoroughfare. Dust and mud were the source of constant complaints from citizens and the business community. A wood-plank walkway, laid across the street at an intersection to help keep pedestrians out of the mud, is visible in the foreground, as is the drainage pipe under the walkway. The trolley tracks and wagon paths in the dirt street are clearly visible. The lower market at Centre Street (5th) is visible in the background. Augustans of the early 1870s suffered from a pollution problem of a different sort than modern Augustans, but both are related to transportation. The evidence of their problem is visible in the near foreground next to the trolley track. (Photographer: J.A. Palmer.)

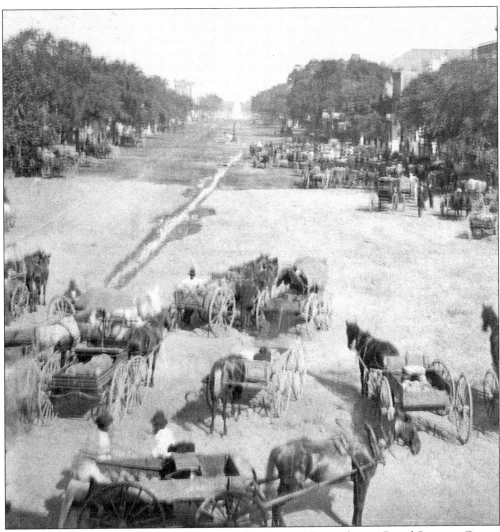

Wagons loaded with fresh produce are crowded in front of the market on Broad Street at Centre Street (5th) around 1873. The upper market at Broad Street and Marbury Street (12th) is barely visible in the background. People buying and selling produce and meat were not the only ones attracted to the lower market—it also attracted some unwanted, unsavory sellers of certain immoral services, to the great annoyance of the respectable people in the community. Broad Street at Centre Street (5th) seemed to be the favorite promenade of these "wretches," as the newspaper called them. An *Augusta Chronicle* article on August 20, 1869, tells of a police raid on the Bridge Row Crowd. "Warrants were issued and three nymphs were arrested and brought up for trial before Justice Ellis. Eurydice Jefferson, described as a cyprian, was charged with leading an idle and profligate life. It was stated that her personal appearance would hardly tempt a modern Orpheus to make a trip to the lower regions on her account. Magdalene, a young maiden who rejoiced in the highly highfalutin and poetical cognomen of Floretta Adams, walked the Grecian bend and wore her hair in a waterfall. Fifteen-year-old Alice Scott, threw herself upon God and her country when asked to plead. All three were all found guilty. Eurydice and Floretta were given the choice of a $30 fine or four months on the chain gang. Alice was given a choice of a $30 fine or six months on the chain gang." There is no word on which choice they made. (Photographer: John Usher Jr.)

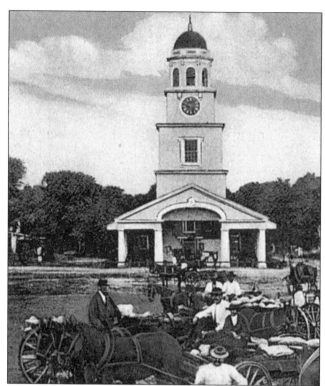

The lower city market at Broad Street and Centre Street (5th) is shown here c. 1873. Watermelon carts are in the foreground. The building existed from 1829 to 1878. It is often referred to as the "Old Slave Market" as slaves auctions were held there before the Civil War, but its main function was as the city market for dealers in meat, provisions, and vegetables. The *Augusta Chronicle* on January 31, 1874, reported that the city made a profit of about $3,500 a year from fees. This postcard was made by S.H. Kress & Co. (Photographer: John Usher Jr.)

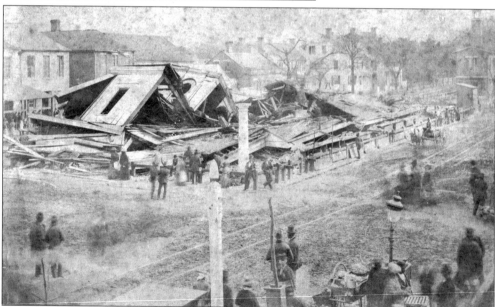

The lower market was destroyed by a cyclone on February 8, 1878. This remarkable photograph shows the wreckage with the infamous haunted pillar still in place. At the right rear is an outhouse that escaped damage. The building with the cupola directly behind the wreckage is the Gazelle Engine Firehouse. The market was rebuilt amid controversy over whether or not it was needed. It lasted until 1892, when it was torn down. (Courtesy Augusta Museum of History.)

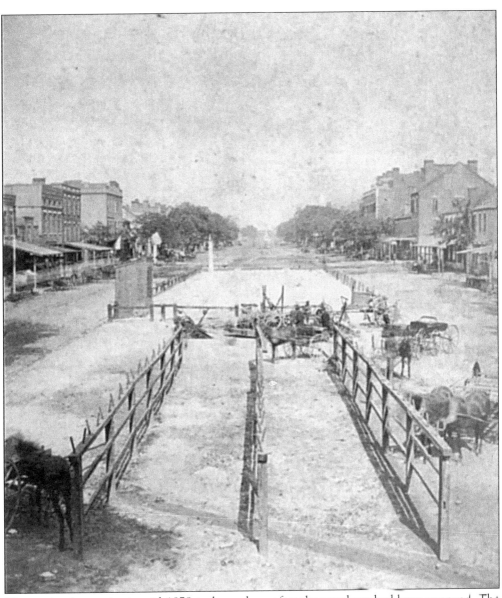

The market house site in mid-1878 is shown here after the wreckage had been removed. The surviving pillar still stands up front. The outhouse also remains. The pillar was moved to the southeast corner of Broad Street and Centre Street (5th) in late 1878, where it remains today. Much lore and superstition has accumulated over a curse placed on the pillar by an itinerant preacher after he was denied permission to preach at the market. He predicted that a big wind would come and destroy the building, leaving a single pillar standing. Anyone who moved the pillar would come to harm. An excellent account of this episode is in the February/March 1990 issue of *Augusta Magazine* titled *The Haunted Pillar, A Sinister Legacy* by Esther Mewihson. The photograph was taken from the Gazelle Engine Firehouse. The first four buildings visible on the left are 462, 464, 466, and 468 Broad Street. The tall building following is 502–504 Broad Street. The first three buildings visible on the right are 461, 463, and 465 Broad Street. The next building is 501 Broad Street, thought to have been built by Ferdinand Phinizy around 1818. (Photographer: J.L. Schaub.)

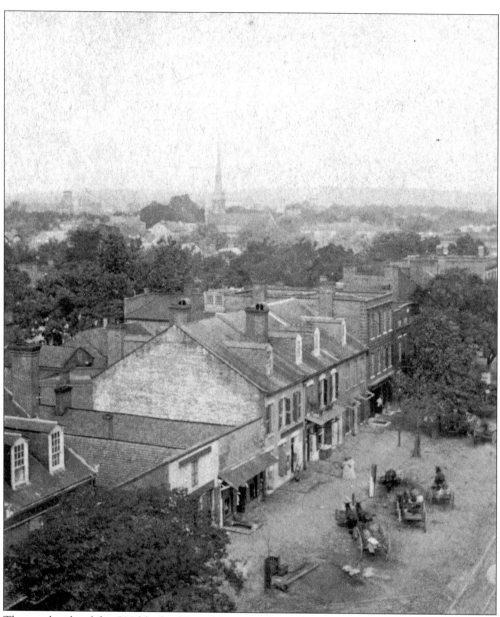

The south side of the 500 block of Broad Street is shown here as it appeared around 1880. The Christian Church steeple is in the center background. The Federal-style building on the far left with the two dormers is 506 Broad Street. The next three buildings are 508, 510, and 512 Broad. The following three Federal-style buildings are 516, 518, and 520 Broad. The adjacent three-story building is 522 Broad. None of these buildings exist any longer. More Federal-style buildings at the west end of the block where Luigi's Restaurant is now located are hidden behind the trees on the right side of the image. Dry good stores, drug stores, grocery stores, saloons, and a toy and tin shop occupied these buildings. The photographer is not identified but was probably J.A. Palmer or John Usher Jr.

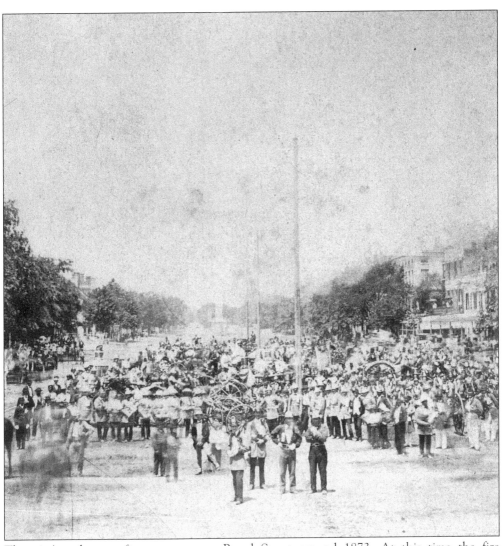

The city's volunteer firemen pose on Broad Street around 1873. At this time the fire department was comprised of nine volunteer companies and two independent companies. In the 1700s the only fire protection Augusta had was a "Bucket Brigade." Engines were not procured until early 1805. The engine was a wagon on which was mounted a manual hand pump and hose. A bucket brigade would pour water into the wagon bed while the fireman operated the pump. To offer better protection the city passed an ordinance in October 1805 requiring every able bodied man in the city to report to the fire when the alarm was given. Failure to report could result in a fine of $20. In 1806 several of the wealthiest citizens of the city were brought before the city council for refusing to assist at a fire. They were fined and admonished not to let it happen again. The city established a paid fire department in 1888 and eliminated the old volunteer system.

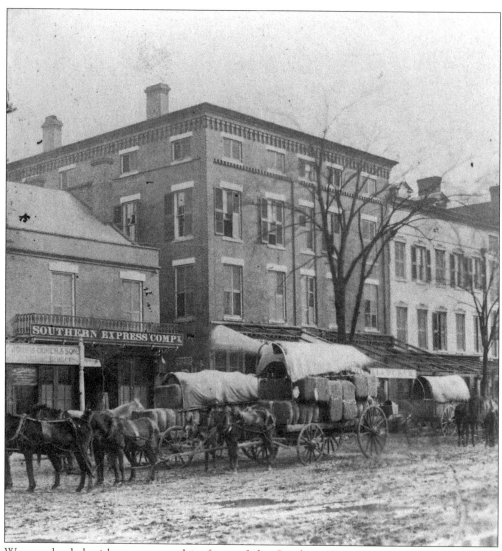

Wagons loaded with cotton stand in front of the Southern Express Company office at 621 Broad Street around 1873. John J. Cohen & Son are located next door at 623 Broad. They were dealers in bonds and stocks. A successful businessman, John Jay Cohen was still in business 20 years later. Behind the wagon in the foreground there is a sign for Miller, Bissel, and Burum, wholesale grocers and commission merchants. The buildings on the right comprise the Augusta Hotel complex at 607 Broad Street. The three-story building to the right of the Southern Express Company building was used as The Soldiers Club by the War Camp Community Service during World War I for use by the men at Camp Hancock. The building was used temporarily by the *Augusta Herald* after the 1916 fire. In 1935 the building was extensively remodeled including a new facade, but a portion of the original building remains today. (Photographer: John Usher Jr.)

This view of the 700 block of Broad Street is interesting because it shows the Chronicle building at 739 under construction in late 1891. Prior to 1892 the *Chronicle* was published across the street at 716 Broad. A fire destroyed the building at 716 Broad on August 27, 1892, and the newspaper moved into its just-completed building at 739 Broad. The building was torn down in 1913 to make way for a new Chronicle building, which opened in December, 1914, but it burned in the fire of 1916. It was rebuilt as the Marion Building, which still stands today. This is an American News Company postcard.

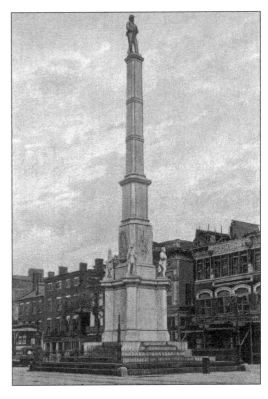

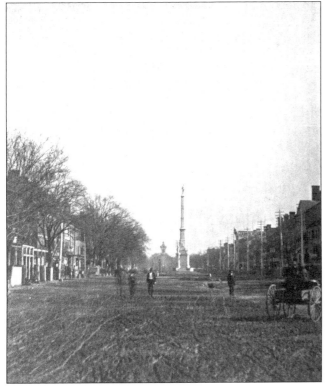

Compare this view of Broad Street at ground level around 1880 with the image on p. 10. The Confederate Monument has been erected. The new lower market building at Centre Street (5th) is visible in the background. The tall building visible about midway across the right side was located at 630 Broad. James A. Gray & Company, wholesaler and retailer of dry goods, occupied the building from about 1870 until 1880. J.A. Palmer was the photographer of this picture. (Courtesy Augusta Museum of History.)

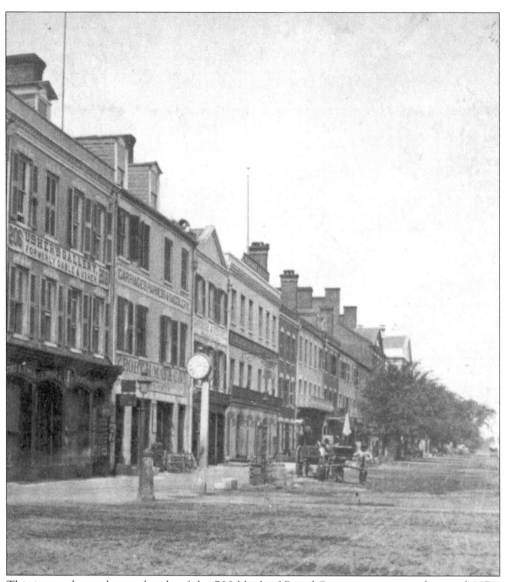

This image shows the south side of the 700 block of Broad Street as it appeared around 1874. The first four businesses can be identified. The photography studio of John Usher Jr. is over the F.A. Brahe Jewelry Store at 702 Broad Street. Robert H. May & Company, manufacturers and dealers of carriages, harnesses, saddlery, leather, etc., occupied 704 Broad. The *Augusta Chronicle* was at 706 Broad. Plumb & Leitner, druggist and dealers in oils, paints, garden seeds, etc., and Platt Bros. Furniture occupied 708 and 710 Broad. The front-gabled roof visible in the background over the top of the trees is the Masonic Temple at 742–744 Broad. (Photographer: John Usher Jr.)

The Globe Hotel on the southeast corner of Broad and Jackson Street (8th) was on of Augusta's oldest landmarks when it burned on February 13, 1887. The Arlington Hotel replaced it. The *Chronicle*, on May 12, 1935, reprinted an article from the early 1880s about the Globe, calling it "A hostelry of honorable antecedent, kept first class by a Southern gentleman." The print is from an 1880 Globe menu. (Courtesy Augusta Museum of History.)

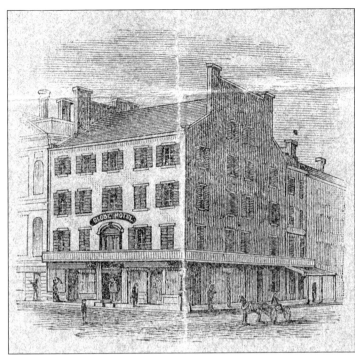

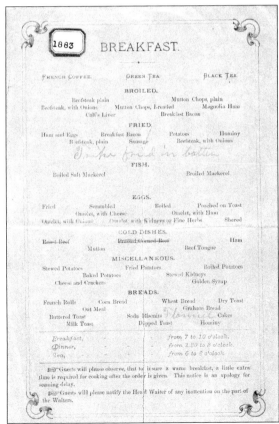

The *Chronicle* article continued: "The table has the best the market affords, the service is thorough, the rooms elegant, and Mr. Brown makes the traveler feel at home." The table must have been well thought of if the breakfast menu is any indication of the hotel's fare—especially if you liked boiled salt mackerel, beef tongue, and stewed kidneys for breakfast. (Courtesy Augusta Museum of History.)

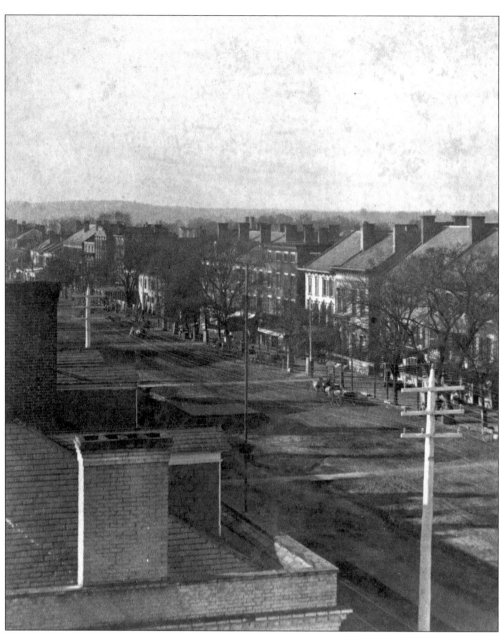

This is a view of the north side of the 700 block of Broad Street between April 1875 and October 1878. The footing for the Confederate Monument can be seen in the middle of Broad Street. Two of the many wood plank crosswalks along Broad can be seen on each side of the footing. The two- and three-story buildings lining the street in this view and the scene on p. 18 are indicative of the architectural styles of the buildings that fronted the commercial sections of Broad Street in the 1870s and 1880s, before skyscrapers began puncturing the skyline. This photograph was taken from the roof of the building on the southeast corner of Broad Street and McIntosh Street (7th). The building in the foreground on the left is 702 Broad Street, where Usher had his studio on the third floor. (Photographer: John Usher Jr.)

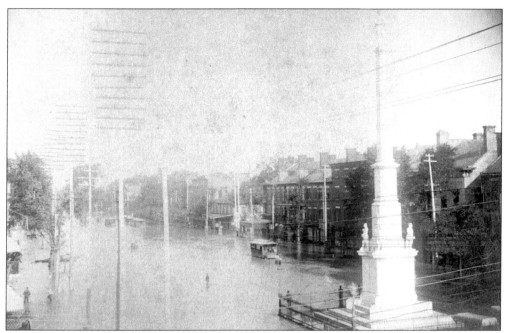

The 700 block of Broad Street is covered by water during the flood of September 10-11, 1888. An abandoned trolley is used by some resourceful citizens to keep dry. The scene is looking up Broad Street to the west from the studio window of the Augusta Art Gallery at 712 Broad Street. The Augusta Art Gallery took both this photograph and the one below.

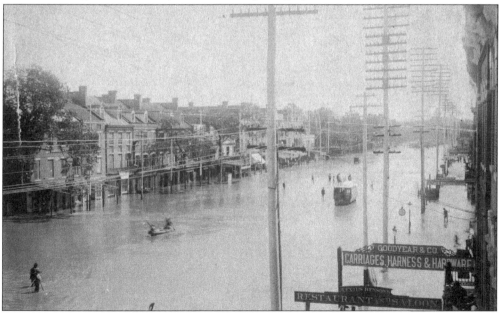

This view looking down Broad Street to the east, from the studio window of the Augusta Art Gallery, shows the floodwaters inundating the stores on the north side of the 600 block. Goodyear & Company at 704 Broad had replaced the old Robert H. May & Co. at the same address. Lexius Henson's restaurant and saloon was at 706 Broad. Henson was an African American whose popular restaurant seated whites only.

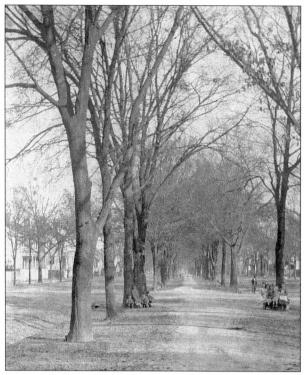

This is a view of the grove on lower Broad Street around 1880. Tree-lined greens were a prominent feature of Broad Street from Centre Street (5th) to East Boundary. (Photographer: John Usher Jr.)

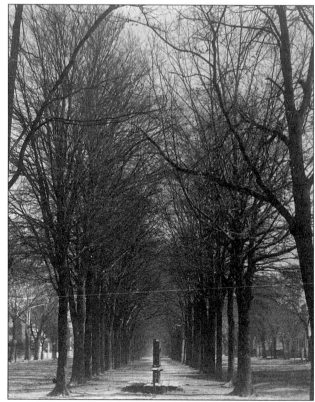

This picture shows the scene on lower Broad Street looking up to the east. This image was issued by Pelot & Cole before 1880. This view may be from one of the negatives of the old Tucker & Perkins views made in 1859.

A ground view of Greene Street in 1874 is shown here. *Leslie's Illustrated Newspaper* in an article dated August 14, 1880, described Greene and Broad this way: "Broad and Greene Streets are two of the finest boulevards in the Union. Greene Street and the upper and lower portions of Broad, especially, are noted for their fine avenues of oaks and elms, and the stranger visiting the city never fails to speak of them in terms of admiration." There is a group of children and adults lined up across the street in the background. As we will soon see they followed the photographer in his every step and happily line up to be in every photograph he made that day. (Photographer: J.A. Palmer.)

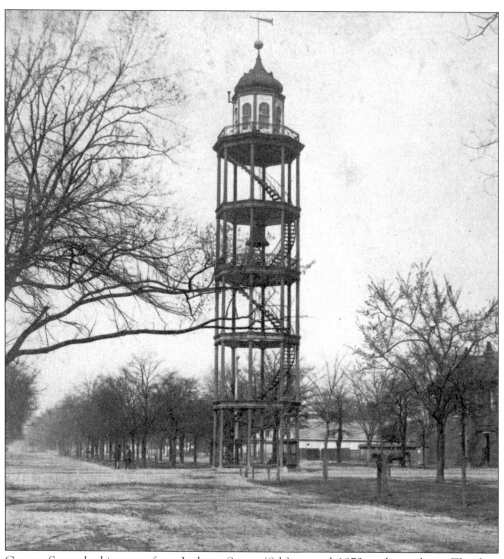

Greene Street looking east from Jackson Street (8th) around 1873 is shown here. The fire-alarm bell tower stands in the middle of the street. The bell tower is a vestige of the old volunteer fire department. It was erected in 1860 and tolled the alarm whenever a fire broke out in any of the nine fire districts in the city. The watchman would toll the bell one time for a fire in district one, two times for a fire in district two, and so on. The bell was christened "Big Steve" in honor of city councilman Stephen Heard, who originated the idea of the alarm tower. After the city leased a Gamewell fire-alarm system in the late 1880s, the position of tower watchman was abolished and the tower fell into disuse. It was torn down in December of 1894. The building at the right side of the image, located on the southeast corner of Greene and Jackson (8th), housed the Pioneer Hook and Ladder company and the Washington Fire Company No. 1 (Hose). (Photographer: John Usher Jr.)

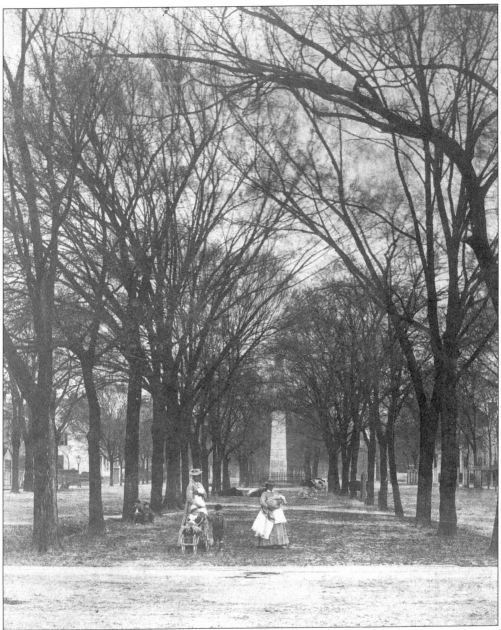

This view shows the green, or park as it was sometimes called, on the corner of Greene and Washington Street (6th) looking east toward the Signers Monument around 1873. Two nannies are on an outing with their wards. Two children huddle up against a tree at the side of the nanny on the left. In spite of being a cosmopolitan city, Augusta maintained rural aspects, as evidenced by the five cows lounging on the green in the background. (Photographer: John Usher Jr.)

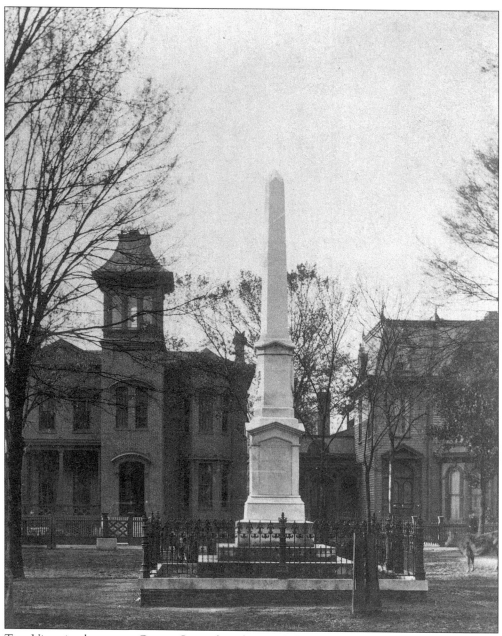

Two Victorian homes on Greene Street face the Confederate Cenotaph, which stands in front of St. James Methodist Church on the 400 block of Greene around 1873. One of Greene Street's ubiquitous cows stands on the green on the right. The house on the left at 436 was torn down when the Gordon Highway was built. The Second Empire-style house on the right at 440 Greene Street still exists. It is currently used as a law office. (Photographer: John Usher Jr.)

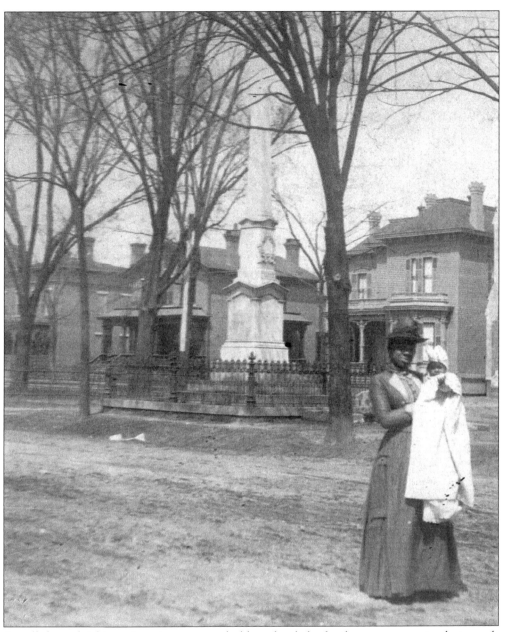

A well-dressed African-American woman holds up her baby for the cameraman to photograph around the mid-1890s. They are standing on the 400 block of Greene Street in front of St. James Methodist Church. The Confederate Cenotaph is in the background on the green. The house adjacent to the church at 447 no longer exists and the space is now the church parking lot. John J. Cohen was the occupant in 1895. The next house at 451 still exists, but it had replaced an earlier Victorian structure around 1900. Asbury Hull was the occupant in 1895. The third house at 453 Greene still exists and is currently used as a law office. W.L. Platt was the occupant in 1895. (Photographer: E.T. Gerry.)

This bird's-eye view of Greene Street was taken from the fire-alarm bell tower at Jackson Street (8th) around 1878. The view is looking east with the Christian Church steeple in the background at McIntosh Street (7th). The roofs of the two houses in the foreground on the left are at 717 and 721 Greene Street. These folks also had to contend with extraneous animals in the vicinity of Greene Street as the fence on the left enclosed the rear of the yard of the Globe Livery Stables on Ellis Street. There was a mule shed in the yard behind the tree at the bottom left corner of the image. (Photographer: J.L. Schaub.)

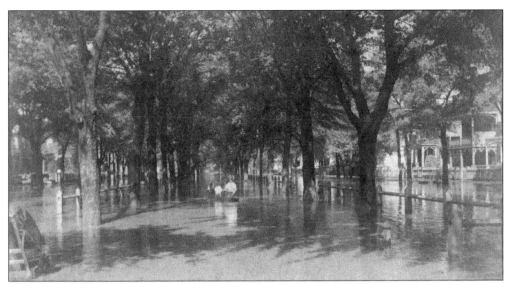

The flood of September 10-11, 1888, not only took its toll on Broad Street but it inundated many of the lovely homes lining tree-shaded Greene Street. This view shows several folks paddling on the green in the 900 block. The cameraman is set up in front of the post office building at Campbell Street (9th) facing west. The house on the right with the two-story front porch appears to be 925 Greene Street. Both this photograph and the one below were issued by the Augusta Photo Company.

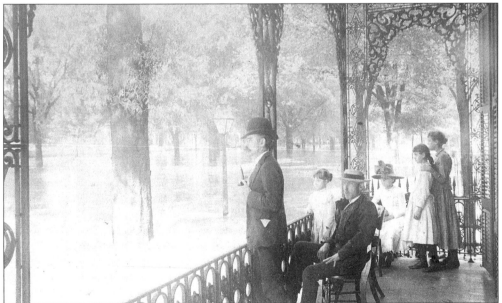

George S. Hookey's family stares out over the flood waters from their home at 465 Greene Street on the northeast corner of Greene and Centre Street (5th) during the flood of September 10-11, 1888. This view is looking west up Greene Street. Hookey was a coal dealer with a reputation for business, energy, and enterprise. At one time he did what had never been done in Augusta—bringing 3,500 tons of coal into the city. He was known to sell none but the best coal. Hookey was also superintendent of the Gas Light Company of Augusta for a number of years.

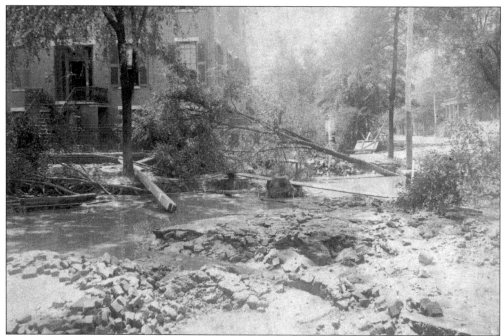

After the waters receded from the flood of September 10-11, 1888, the severe damage caused by the rushing waters became evident. A bad washout is shown in this image taken at the corner of Greene and McIntosh Streets. Edward P. Clayton's house, built by Major George L. Twiggs around 1839, is in the background at 638 Greene on the southeast corner. It was torn down about 1950 and replaced by a bus station. Both this photograph and the one below were issued by the Augusta Photo Company.

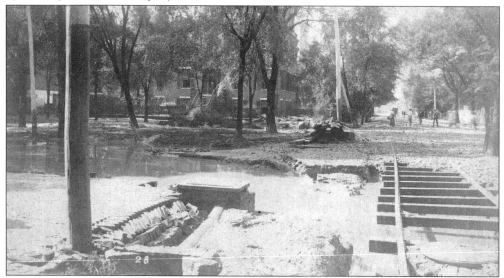

More severe flood damage is evident in this photograph taken after the waters had receded from the flood. This view is looking south on McIntosh Street (7th) from beside the Christian Church at the northeast corner of Greene and McIntosh Streets. The damaged track had been placed on McIntosh Street in order for the trolley to carry passengers to and from the Georgia Railroad Exposition Depot.

Two
MONUMENTS, PARKS, AND CEMETERIES

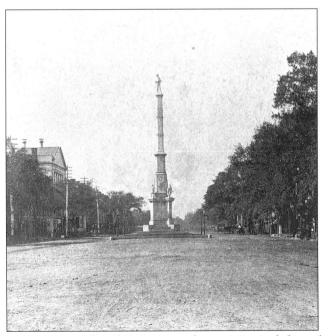

The Confederate Monument on Broad Street, raised in memory of those from Richmond County who died in the Civil War, is the focus of this image taken in 1880. The building on the left rising above the trees is the Masonic Temple, which was built in 1829 and demolished in 1880. A sign on the left reads "Henry S. Jordan, The Clothier." The 736 address dates this photo after January 1, 1880. (Photographer: John Usher Jr.)

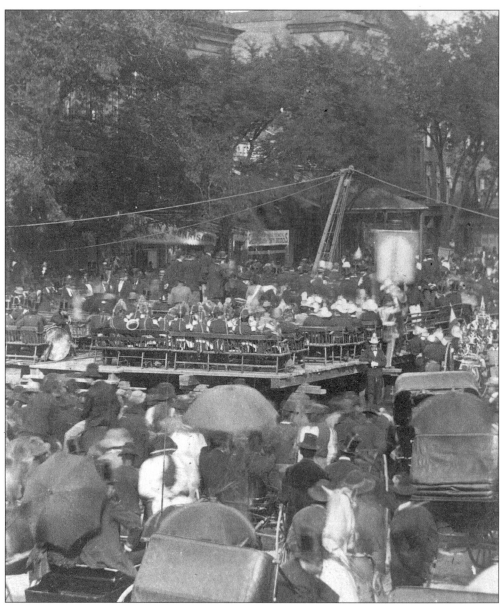

This remarkable and rare photograph is of the ceremony for laying the cornerstone of the Confederate Monument on Broad Street on April 26, 1875. The block and tackle rigging used to lift the stone is visible in the background. Someone is holding up a banner just to the right of the rigging. A band is seated on the elevated platform. Many people are watching from their carriages. The *Chronicle* of April 27, 1875, recorded that the program included Masonic ceremonies for the laying of the cornerstone. Numerous religious, governmental, social, educational, and miscellaneous items were included in the copper box placed under the cornerstone. After the dedication the first Memorial Day parade took place when the participants marched to Magnolia Cemetery to decorate the graves of Confederate soldiers. The Ladies Memorial Association of Augusta later sold views of the laying of the cornerstone from the negatives of J.A. Palmer and John User Jr. in order to raise money for the Memorial Fund. The photographer of this picture was John Usher Jr. (Courtesy Michael W. Griffith.)

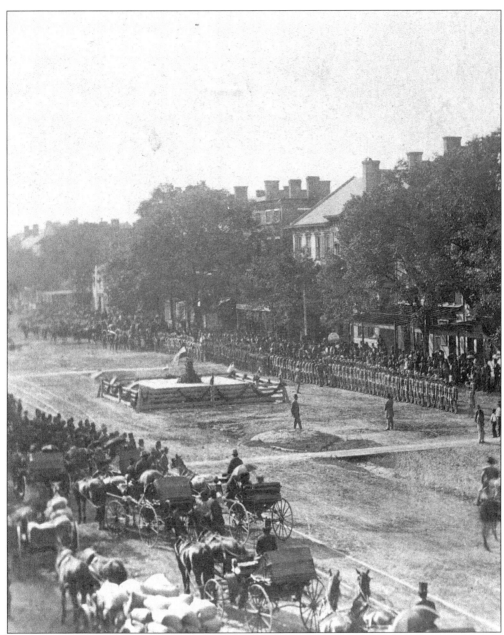

An important ceremony is about to take place beside the footing of the Confederate Monument on Broad Street around 1877. Some of Augusta's military companies are lined up on the north side of the street. Large crowds have gathered on both sides of the street. Memorial Day ceremonies were held annually on April 26 at the site. Afterwards the participants would march to the City Cemetery (Magnolia Cemetery) to lay flowers on the graves of Confederate soldiers. Perhaps a Memorial Day ceremony shown here. (Photographer: John Usher Jr.)

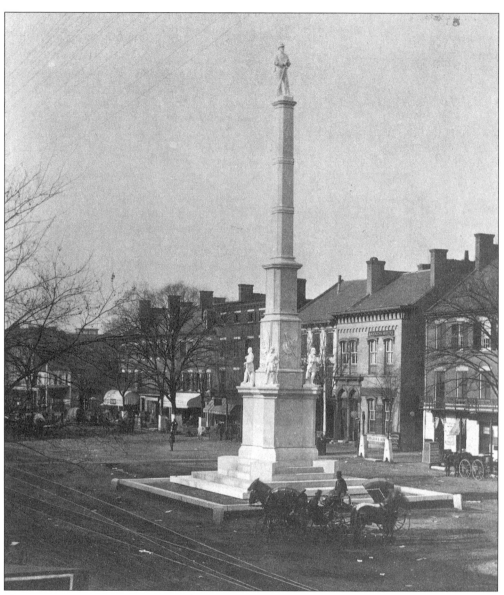

Here we see Augusta's new, graceful, gleaming Confederate Monument, erected by the Ladies Memorial Association, as it appeared soon after it had been raised. The Ladies Memorial Association was formed on April 26, 1868, as an offspring of the Ladies Relief and Hospital Association of Civil War Days. Their objectives were to take care of the soldiers' graves in Magnolia Cemetery and to erect a monument to the Confederate dead. After being reorganized in 1872, they began in earnest to collect money in a memorial fund to purchase a monument. After obtaining the necessary money the association had the monument designed in Philadelphia and the work executed in Carrara, Italy, from pure Italian marble. The cornerstone was laid on April 26, 1875. Three years later, on October 31, 1878, the monument was dedicated with imposing ceremonies. It is 72 feet high and sits on a 4-foot-high foundation, making the total height 76 feet. The base, which is of Georgia granite, is 22 square feet. The monument was assembled by Theodore Markwalter's Steam Marble and Granite Works of Augusta. (Photographer: J.A. Palmer)

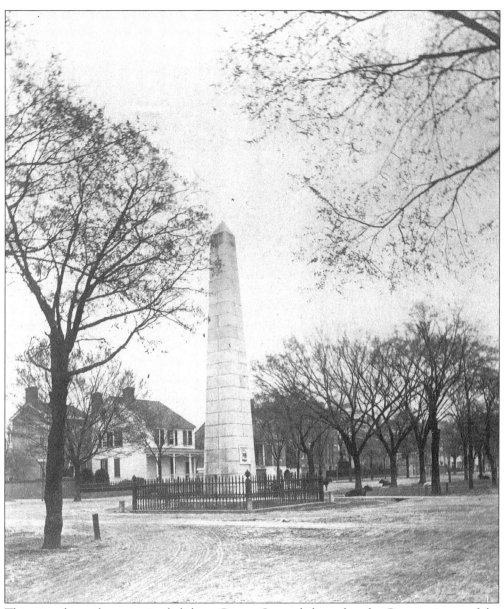

This view shows the majestic obelisk on Greene Street dedicated to the Georgia signers of the Declaration of Independence (c. 1873). The three signers were George Walton (an Augustan), Lyman Hall, and Button Gwinnett. On the south side near the base is a slab carved with the coat of arms of Georgia. The names Hall, Gwinnett, and Walton are carved around the seal. The remains of Hall and Walton are buried at the base of the monument. Located on the 500 block, it stands in front of the courthouse at the intersection of Monument Street. This view is looking northeast. The house to the left of the monument was 539 Greene Street. It was subsequently replaced by another structure that was replaced by the Poteet Funeral Home chapel. The ubiquitous Greene Street cows lounge around the green on the far side. (Photographer: John Usher Jr.)

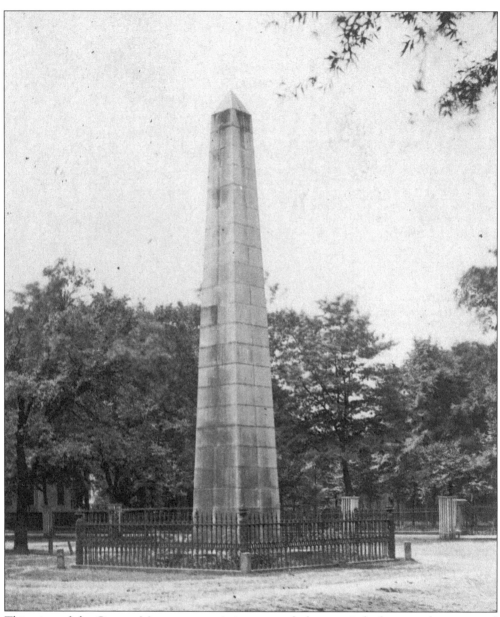

This view of the Signers Monument, as it is commonly known, is looking southeast around 1873. Built of light-gray Georgia granite, it stands nearly 50 feet high. The cornerstone was laid on July 4, 1848, with Masonic ceremonies. A box under the cornerstone contained local papers, coins, and other items of interest to remote posterity. The city experienced problems with several contractors over the erection of the monument. It was not completed until 1852. An iron railing was erected around the base in 1855. In 1891 work began on improvements to the courthouse. Flanking wings were added. The level of the yard was raised, as was the level of Greene Street. The monument was dismantled and a new base was constructed to conform to the new elevation. The monument was then rebuilt as it stands today. (Photographer: John Usher Jr.)

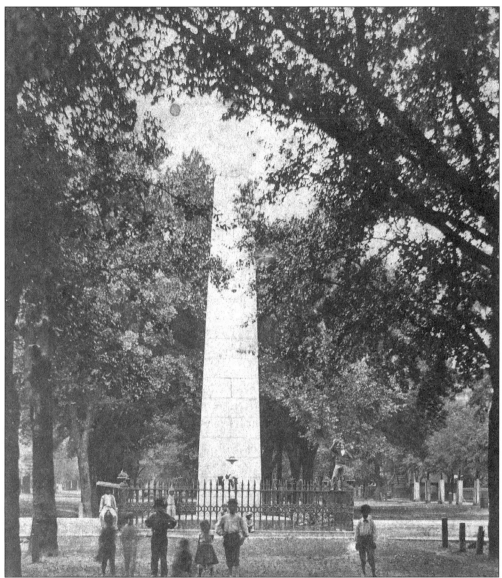

This photo shows the Signers Monument as it appeared from the middle of the green looking east around 1874. Some of the group of children and adults that were mentioned in the photograph on p. 23 have following the photographer as he makes his way along Greene Street. They include an African-American man with what appears to be a breadboard balanced on his head. There are white and African-American children in the group, including one cute young lady dressed in pantalettes. (Photographer: J.A. Palmer.)

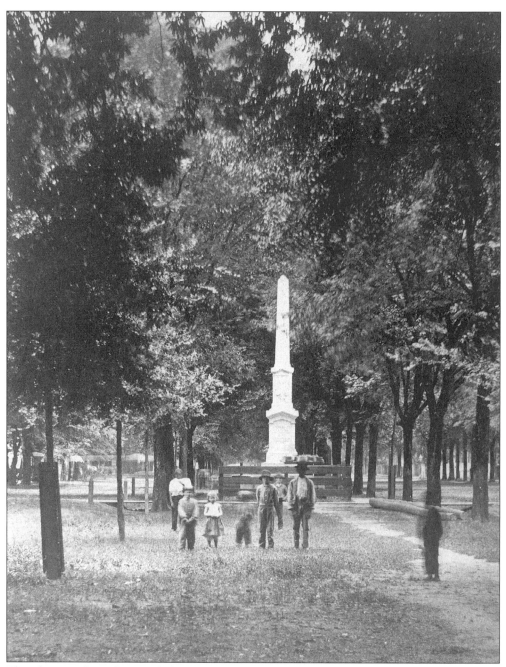

The photographer, along with his rag-tag group, has moved east to the 400 block of Greene Street near the Confederate Cenotaph in front of St. James Methodist Church around 1874. The man with the breadboard on his head poses along with the young miss dressed in her pantalettes. This view is interesting as the poles used in the block and tackle rigging to raise the cenotaph in late 1873 are lying on the ground beside the monument. A temporary wood fence surrounds the structure. (Photographer: J.A. Palmer.)

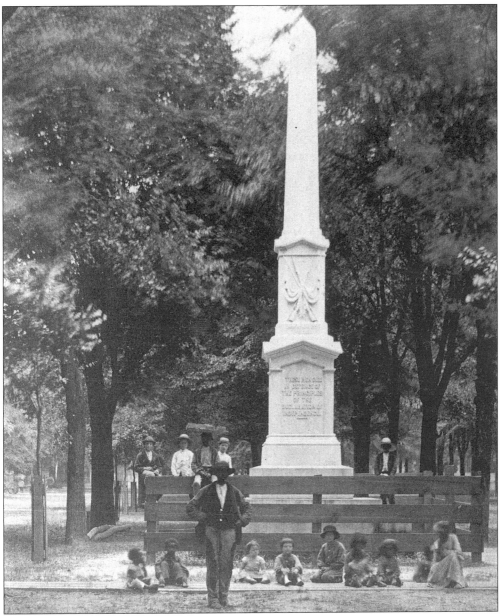

The Confederate Cenotaph is shown up close with the same group posing for the photographer, including the man with the breadboard on his head and the young miss in her pantalettes, around 1874. The St. James Methodist Church Sunday School began a movement in October 1865 to erect a monument to the 24 members of their church who died in the Civil War. Later the plan was expanded to include all 292 men from Richmond County who gave their lives for the "Lost Cause." The cornerstone was laid with Masonic rites on April 26, 1873. The box placed under the cornerstone contained rolls of past and present members of local military companies, Confederate money, United States coins, a Bible, and other miscellaneous items. The cenotaph was dedicated on December 31, 1873, at half-past three o'clock and was watched by one of the largest crowds assembled in the city since the Civil War. (Photographer: J.A. Palmer.)

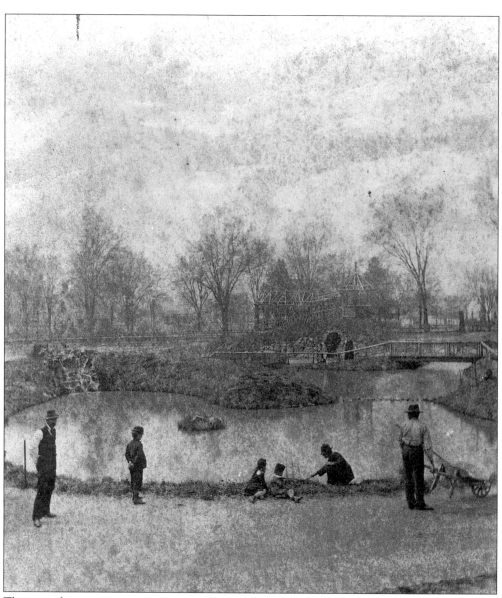

The next three views are rare scenes of May Park soon after work commenced on it in 1880. *Harper's Weekly* was impressed with the park and had this to say in an article from February 26, 1887: "That it (Augusta) is a city so well provided with the necessities of existence that it feels able to afford some of its luxuries as well, is shown by the dainty little 10-acre park occupying the two blocks bounded by Fenwick, Lincoln, Elbert and Calhoun streets. It was begun in 1880, since which time about $4,000 has been expended upon it each year, until now it contains a lake, fountains, a cascade, rustic houses and seats, rock arches, winding walks, and quantities of thrifty trees, ornamental shrubs, and flowering plants. It is called 'May Park,' in honor of the present Mayor of Augusta, Robert H. May, who suggested the idea for a park, and has been most active in arranging and carrying out the details of the work. Mr. May has been for thirteen years Mayor of Augusta, and no stranger who is so fortunate as to enjoy his acquaintance can fail to be pleasantly impressed with the city whose affairs he so largely controls." (Photographer: John Usher Jr.)

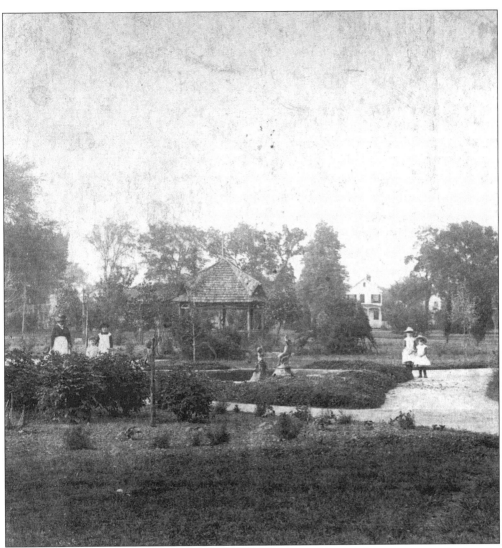

In this view of May Park taken around 1884 some young children and a nanny are enjoying the walks, fountains, rustic houses, trees, and shrubs of the park. In the previous view on p. 40 a portion of the lake and its pedestrian bridge can be seen. Some of the small children are watching what appears to be park maintenance workers performing some maintenance task. (Photographer: M.L. Cormany.)

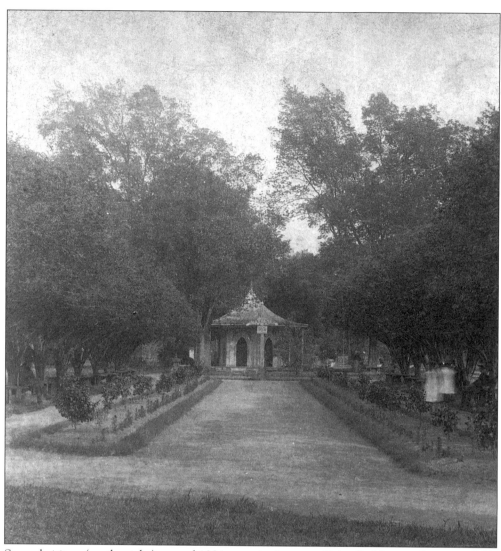

Several visitors (on the right) around 1884 are enjoying one of May Park's rustic houses with its formal landscaped flower beds. Another early city park named for an Augusta mayor was Allen Park. Allen Park was developed early in the 20th century at what is now Walton Way and Fifteenth Street. It was named for Mayor Richard E. "Dick" Alle, who was mayor from 1904 to 1907. Allen Park has been eliminated by commercial development. May Park still exists but it does not retain any of the features described above. (Photographer: M.L. Cormany.)

The fountain in the middle of the 500 block of Broad Street, at Monument Street, was built around 1869. Soon after it was installed the *Chronicle* ran the following note on October 3, 1869: "It is related of a certain Sheriff that, when the Broad street Fountain was first erected, on coming out of an adjacent store, one night, he heard the falling of the waters, and raised his umbrella, walking a whole square before he discovered that it was not raining, but was, on the contrary, a bright starlight night! But such things happen occasionally." The building on the right at 566–568 Broad Street still exists today. The Signers Monument and the courthouse can be seen in the distance. (Photographer: John Usher Jr.)

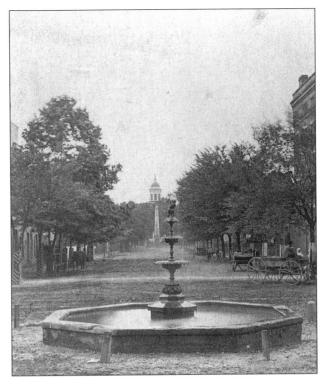

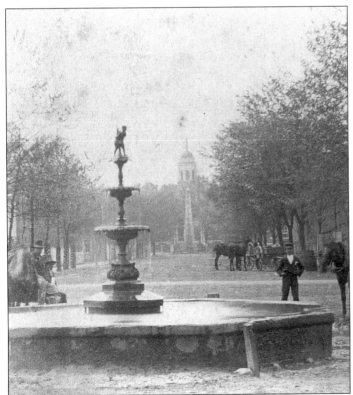

This view is a close-up of the fountain on Broad Street, at Monument Street, with the Signers Monument and the courthouse in the distance. A note inscribed on the back of the stereo view card says "Augusta Fountain, April 16, 1874." (Photographer: J.A. Palmer.)

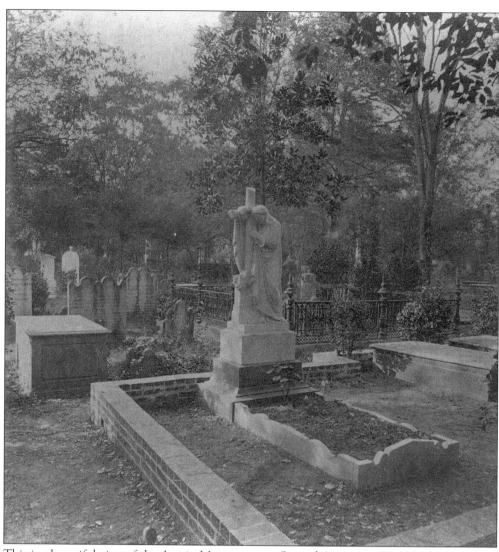

This is a beautiful view of the Austin Monument on Second Avenue at De L'Aigle Avenue in the old portion of the City Cemetery (Magnolia Cemetery) in 1872. The monument still stands but the coping is gone and the ground level has risen so much from the silt deposited by floods that the wall is no longer visible and the tops of the sarcophaguses are flush with the ground. This monument is in memory of Mrs. Ann Austin, the daughter of M. and Ann Kinchley, born in Augusta on January 25, 1825. She married Robert Austin on December 20, 1841, in Augusta, and died on January 21, 1872. (Photographer: J.W. Perkins.)

This is a southeast view of the T.R. Rhodes section located west of De L'Aigle Avenue on the south side of Eighth Street around 1873. The latest date in this section is that of T.R. Rhodes, who died February 13, 1872. The latest date found on the other monuments in this view is May 20, 1873. This section was in the new portion of the cemetery in 1873. (Photographer: John Usher Jr.)

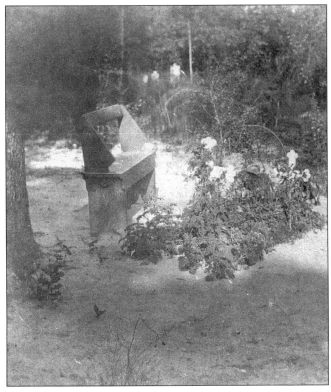

The photographer recorded a recent burial in an unidentified plot in the City Cemetery (Magnolia Cemetery) in this 1867 view. The *Summerville Cemetery, Augusta, Georgia*, compiled by the Augusta Genealogy Society, Inc., stated the importance of cemetery benches. The bench is noteworthy as it "had become an important part of the burial plot's design during the Rural Cemetery Movement in 19th-century America. As in home gardens, where one rested on a bench under a favorite tree, the cemetery bench became an important part of the plot's design, to be enjoyed while contemplating the state of one's soul as one visited the 'slumberers'." (Photographer: J.W. Perkins.)

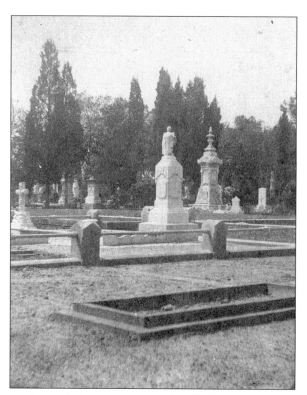

E.T. Gerry, an itinerant photographer passing through Augusta, took a series of photos in the City Cemetery (Magnolia Cemetery) in the mid-1890s. Cemeteries were a popular subject for stereo photographers during "the Rural Cemetery Movement in 19th-century America. Their park-like settings were places where families would come with their picnic lunches and spend an afternoon with both past and present family members." (*Summerville Cemetery, Augusta, Georgia*, compiled by Augusta Genealogy Society, Inc., 1990). Gerry took the next five images. This image is of the Boulineau family section adjacent to the Adams family section on the south side. The view is looking southeast. The stone fence posts on the Boulineau section remain in place today but the iron rails are missing.

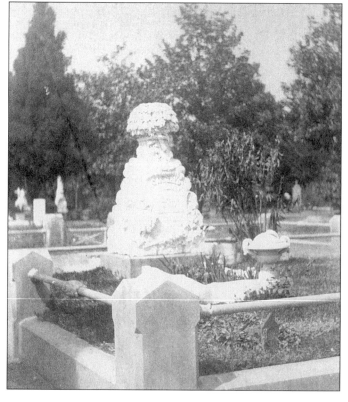

This image is of the Adams family section in the City Cemetery (Magnolia Cemetery) that is adjacent to the Boulineau section on the north side. The stone fence posts and the iron rails still surround the Adams section. The two sections are located on the south side of Eighth Street west of De L'Aigle Street. (Photographer: E.T. Gerry.)

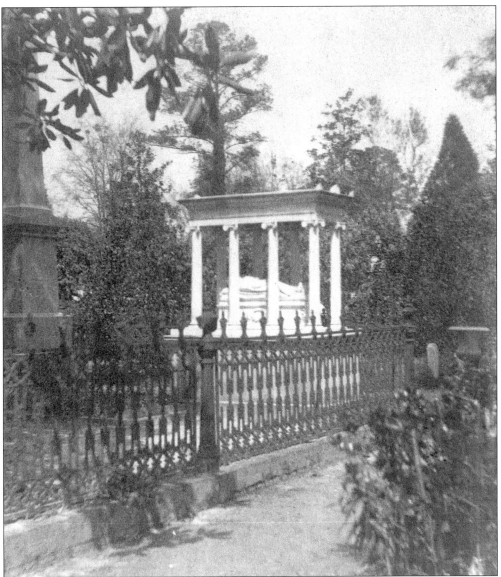

The beautiful monument to young Eugene B. McCay (1855–56) with its sarcophagus topped by a canopy supported by Ionic columns is the focus of this view of the McCay family section. It is located on the north side of Fourth Street just west of Estes Avenue. McCay died out of town and was not buried in the City Cemetery until August 21, 1858. The decorative fence has not survived. (Photographer: E.T. Gerry.)

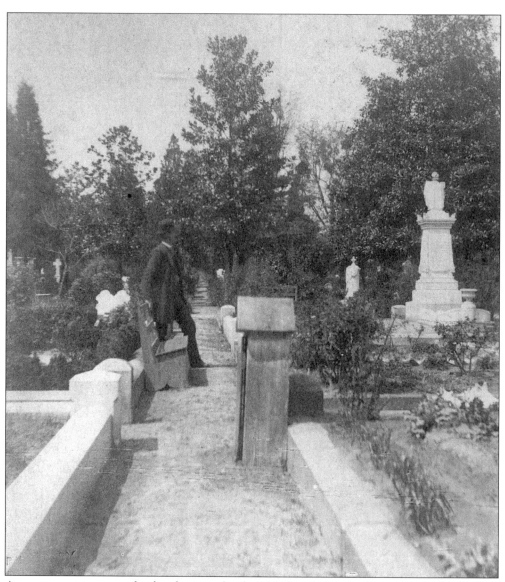

A cemetery visitor poses for the photographer beside a bench that is adjacent to the Bredenburg family section. It is located on the north side of Fourth Street just east of Estes Avenue. Mayor Robert H. May made this report on cemeteries in the 1890 City Yearbook: "The cemetery for whites is one of the institutions of Augusta to which we point with mournful pride. There rest the ashes of our beloved dead in silent repose. There the loves, the hopes, the ambitions of many of us lie buried, and there our ladies go, with loving care, to keep green the graves of relatives and friends. It is a high and holy cause to which, with affectionate zeal, they devote themselves: and for their sakes as well as for the sacredness of this great interest, I suggest that you continue with liberal hands to provide for its proper maintenance, the preservation of its memorials, the care of its avenues and walks, and the general attention to its mournful attractiveness. The cemetery for colored people is also a credit to that class of our citizens. You have given many sections in it to benevolent societies —and they, with a tender regard for their poorer brethren, give them decent interment. I make the same recommendation in regard to this as I have in regard to the cemetery for whites." (Photographer: E.T. Gerry.)

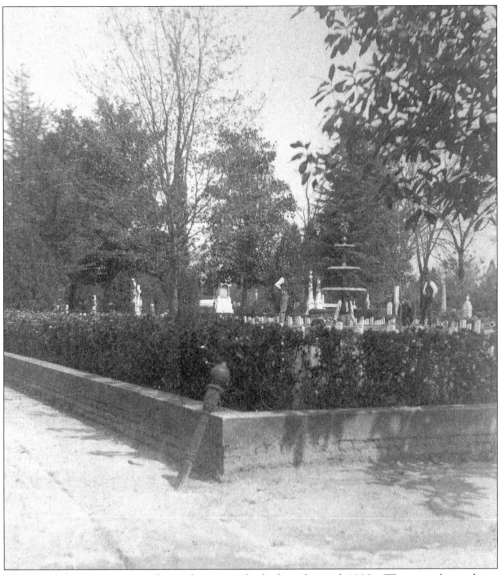

The Confederate section is shown here as it looked in the mid-1890s. Three workman have stopped to pose for the photographer. In the mid-1870s the Ladies Memorial Association set out to put the soldiers' section in order. The Confederate dead were gathered together and buried in the section. It was enclosed with a substantial stone coping. The section was sodded and a fountain was erected in the center. A slab of marble, bearing the name, company, regiment, and state of the deceased was placed on each grave. The Confederate section is located on Estes Avenue between Fourth and Fifth Streets. (Photographer: E.T. Gerry.)

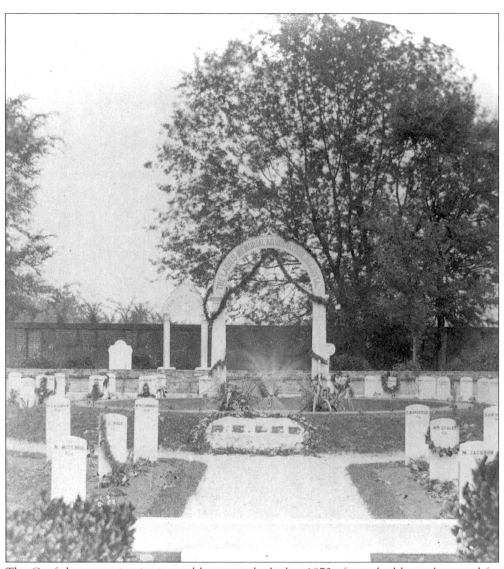

The Confederate section is pictured here as it looked c. 1872 after it had been decorated for Confederate Memorial Day. The Ladies Memorial Association of Augusta erected the arch. Some of the stones have garlands on them. The names on the eight stones in the foreground on each side of the center walkway are legible. It is interesting to note that the stones in place today are not all arranged in the same manner. In 1873, starting at lower left and going clockwise, the names were Mitchell, Wolf, Farrow, Cumming, Barfield, McIntosh, Scales, and Jackson. Today the stones in the same locations read Mitchell, Criswell, Farrow, Cumming, Loyd, Barfield, Scales, and Hill. The numerous floods over the years that have covered the cemetery toppled the stones. Some of them were misplaced when they were restored to the site. This stereo view was issued by the Littleton View Co. in the 1890s, but the original photographer was probably John Usher Jr.

Three
AROUND TOWN

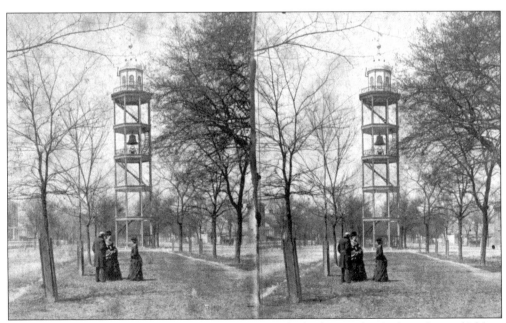

The grove on Greene Street, with the bell tower in the background at Jackson Street (8th), is shown here in stereo view format around 1873. The lady on the right is dressed in an early 1870s-style dress with the requisite bustle. The gentleman wears a long frock coat with a wide shawl collar. He holds a high silk hat, which is somewhat unusual, as they were rarely used in the daytime during this period. (Photographer: John Usher Jr.)

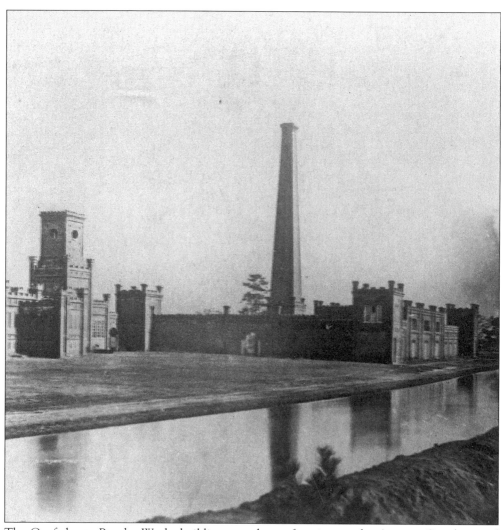

The Confederate Powder Works buildings are shown fronting on the Augusta Canal around 1870. This view is looking southeast. Designed by engineer C. Shaler Smith with Romanesque and Gothic details and constructed in 1861 under the guidance of George Washington Rains, the powder works provided more than 2.75 million pounds of high-quality gunpowder to Confederate troops during the Civil War. The building to the right, 50 feet back from the canal, surrounding the obelisk chimney, was the refinery where several major operations at the beginning of the gunpowder-making process took place. The building on the left, about 160 feet back from the canal, was the laboratory, where chemical analysis and testing of the gunpowder ingredients was done. All that remains of the only permanent structure built by the Confederate government is the obelisk chimney. It stands, at the request of George Washington Rains, as a memorial to the Confederate dead. The Civil War-era canal was only 48 feet wide and 7 feet deep at this point. Today Goodrich Street runs through the site of the front of the refinery next to the canal. This photograph was taken by J.W. Perkins. (Text courtesy of Michael C. White.)

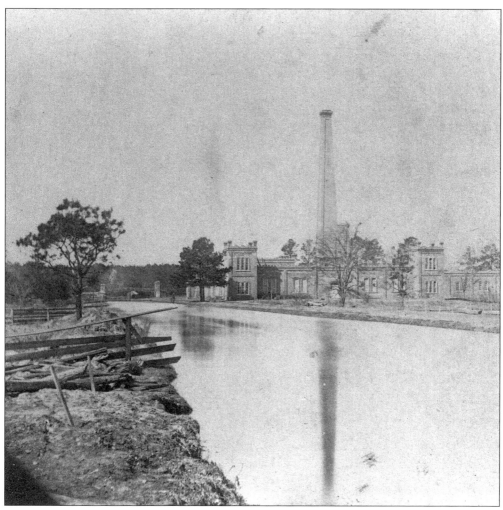

This view of the Confederate Powder Works buildings fronting the Augusta Canal is rarely published. It was taken looking northwest around 1870. The southeast end of the refinery building can be seen next to the canal. The building to the right of the rear tower, behind the refinery building, is the wood shed where wood from willows and cottonwood trees was stored and made ready for use in the charcoal manufacturing room of the refinery. Looking up the canal a bridge over the water can be seen. It was located approximately where the Brown Lane's Bridge is located today. These buildings anchored the southern end of the Powder Works complex, which extended more than 10,000 feet along the canal to the north and consisted of 9 divisions and 14 buildings. The buildings were demolished in the late 1870s. This photo was taken by John Usher Jr. (Text courtesy of Michael C. White.)

This rare early view of Broad Street was taken around 1859. The three-story, front-gabled building is the Masonic Temple at 742–744 Broad. It was constructed around 1828 and was torn down in 1880 after being found to be structurally unsafe. The sign advertising pianos, books, and music was for the business of George A. Oates & Brothers, Booksellers. Next door was Hickman, Hills & Cress, Dry Goods Merchants. The photographers were Tucker & Perkins. (Courtesy Augusta Museum of History.)

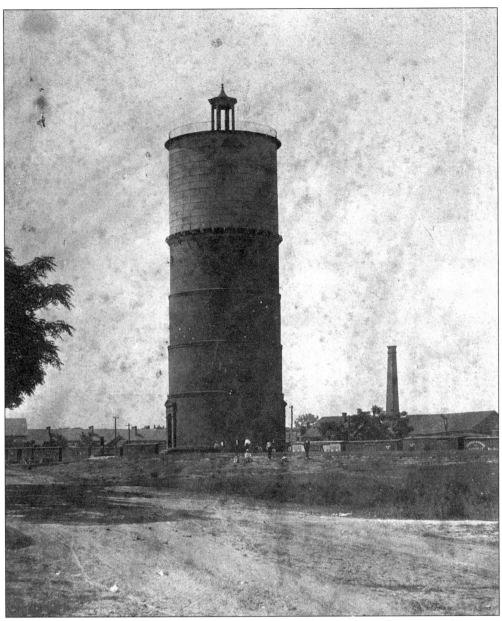

This c. 1873 view shows the elevated cast-iron water tank built in the early 1860s on Cumming Street (10th) at the intersection with Fenwick Street. The buildings and chimney in the background are George R. Lombard's Forest City Foundry. According to Thomas Heard Robertson's "Notes on the Development of the Augusta Water Works, 1822–1901," published in the spring of 1977 in *The Georgia Operator*, "The tank was 37 feet in diameter and was elevated 94 feet above the ground on a brick base. The center of the tank was hollow and contained a stairway leading to an observation platform atop the reservoir. The tank was part of the Canal Water Works designed by Mr. William Phillips, a local civil engineer. The system was designed to supply water under pressure for watering the streets, washing the drains during dry weather, bathing, and extinguishing fires. The Turknett Springs Water Works supplied water for drinking and culinary purposes." (Photographer: John Usher Jr.)

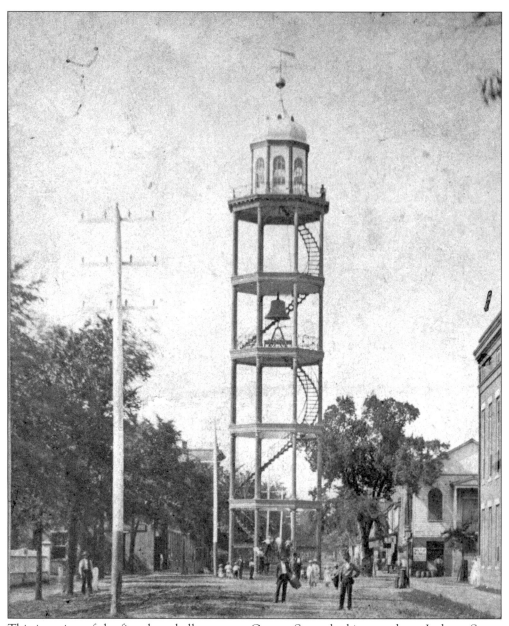

This is a view of the fire-alarm bell tower on Greene Street looking north on Jackson Street around 1874. In April 1862 the ordinance governing the fire companies was changed to read "fire department" and Mr. Jacob B. Platt Sr. was elected the first chief engineer under the new ordinance. He served as chief until March 1869. On March 31, 1884, Mr. W. Edward Platt was elected chief engineer. He was the last chief of the volunteer fire department, as it became a paid department on January 12, 1888. Mr. R.J. Bowe constructed the two-story brick building on the right in 1859. It housed the Pioneer Hook and Ladder Company and the Washington Fire Company No. 1 (Hose). This building still exists today. This photograph was taken by J.A. Palmer. (Courtesy Augusta Museum of History.)

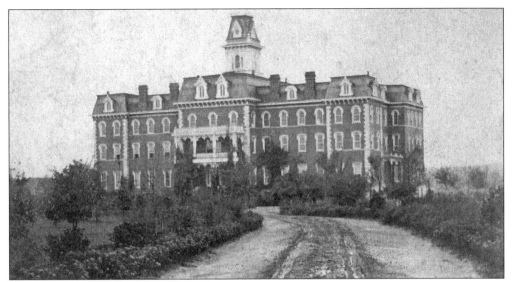

The Augusta Orphan Asylum was located on Railroad Avenue (R.A. Dent Boulevard) at Harper Street. This photograph was taken around 1880. The architect was D.B. Woodruff of Macon, GA, and the builder was William H. Goodrich of Augusta. It opened in August 1873. (Photographer: John Usher Jr.)

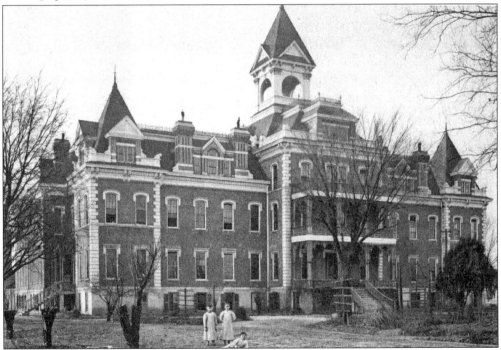

The Orphan Asylum burned on August 21, 1889. There was no loss of life. The exterior walls were used when the Orphan Asylum was rebuilt and reopened on December 24, 1890. The building was similar to the original. After the orphan facility was moved to Gracewood, GA, in 1912, the Medical College of Georgia moved into the building. It was torn down in 1960. (Published by A.F. Pendleton, Bookseller and Stationer, Augusta, GA. The Albertype Co., N.Y.)

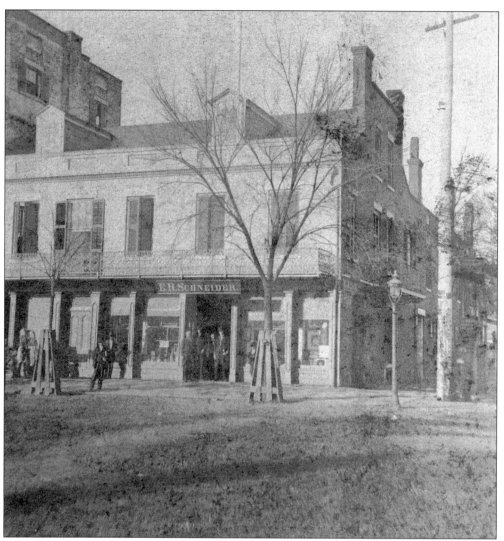

Ernest R. Schneider, located at 601 Broad Street on the northwest corner at Washington Street (6th), sold fine wines, liquors, Havana cigars, mineral waters, and groceries. This photograph was taken around 1880. It is a Federal-style building, constructed before 1836, with a cast-iron front. Schneider purchased the building in 1873. It was sold to the Erbelding family in the late 1920s. Knox Realty renovated the building for business use in 1983. The building still exists but it is now vacant. The building to the left is the Augusta Hotel. (Photographer: J.A. Palmer.)

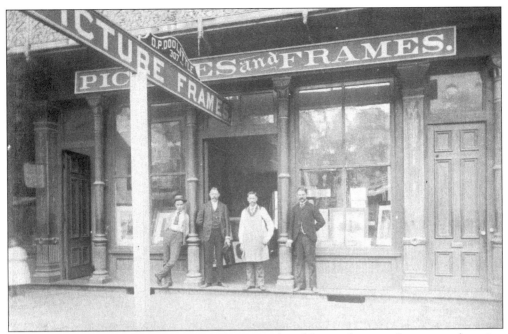

Oliver P. Doolittle and Samuel E. Doolittle operated a gilding and picture-frame manufacturing store at 126 Jackson Street (8th) from 1886 to 1889. They also installed room molding and carried a line of engravings. Oliver Doolittle was subsequently the manager of the Augusta Picture Frame Company at 309 McIntosh Street (7th). (Courtesy Augusta Museum of History.)

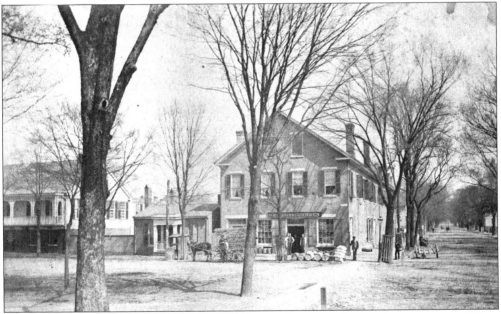

Richers & Gehrken's Store is shown at 401 Greene Street on the northeast corner at Elbert Street (4th) around 1895. Christian Richers and Fred Gehrken were wholesale and retail grocers dealing in liquors, cigars, tobacco, and fancy groceries. They superseded N. Kahrs & Company grocers in 1883 and were still in business after 1900. The building still exists but the two houses on the left of the store did not survive. (Courtesy Augusta Museum of History.)

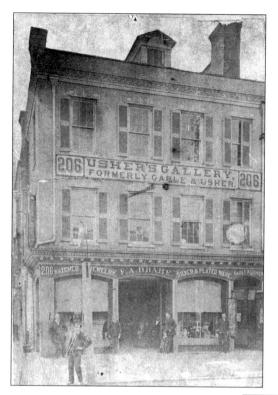

A large sign on the building on the southwest corner of Broad Street and McIntosh Street (7th) prominently advertises Usher's Gallery at 206 Broad in the 1870s. In 1880 the address was changed to 702. The entrance to the gallery is through the doorway on the right side of the building. The F.A. Brahe Jewelry Store occupied the first floor. The William Schweigert Jewelry Store superseded Brahe around 1886 and continued in business well into the 1900s. The photographer of this image was probably John Usher Jr. (Courtesy Augusta Museum of History.)

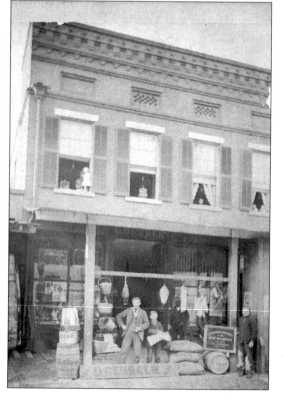

Dietrich Gehrken operated a grocery store and saloon at 466 Broad Street in the 1880s. The family resided over the store, as evidenced by the child looking out of the window. She has propped up a doll on the window sill. The 1884 Augusta City Directory listed 223 grocers in competition with Gehrken. This building can be seen in the image on p. 13 as well. The building still exists. (Courtesy Augusta Museum of History.)

Charles A. Platt, a native of Connecticut, arrived in Augusta around 1837 and founded C.A. Platt & Company, a furniture and piano forte store on Broad Street. He also sold coffins and practiced undertaking. Charles died in 1887 and his son, W. Edward Platt, assumed control of the business. In 1890 W. Edward Platt discontinued the furniture business and concentrated entirely on undertaking. The Platt's Funeral Home business is now 163 years old. This photo was taken around 1885. (Photographer: Bairstow, Warren, PA.)

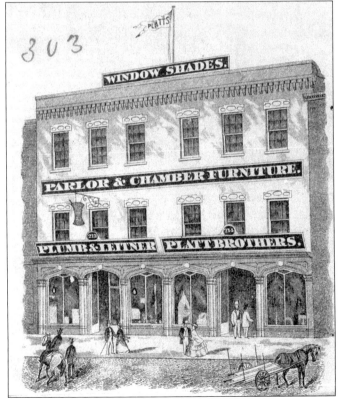

Platt's furniture and undertaking business was located at 710 Broad Street from the 1850s until the furniture business was closed in 1890 and W. Edward Platt moved his undertaking business to 301 McIntosh Street (7th). The flagpole with the flag bearing the "Platt Bros." name was erected October 14, 1869. Shown here is an engraving from a Platt Brother's billhead from around 1875. (Courtesy Augusta Museum of History.)

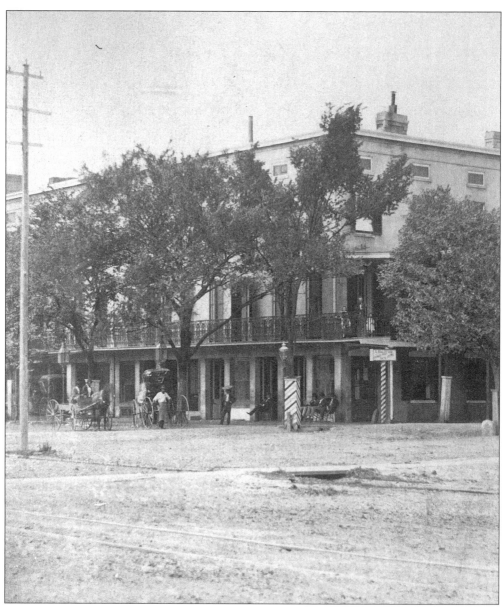

The Planters Hotel was located at 945 Broad Street at the northwest corner of Macartan Street. This building, the second Planters Hotel, is shown here around 1873. The first Planters Hotel was located on the northeast corner of Jones Street and Macartan Street. It burned on May 25, 1839. A *Chronicle* article from August 1868 had this to say about the Planters: "Now that the first bales (of cotton) have come in, heralding the return of busy times and many visitors, we can look forward to corresponding changes in the Planter's. The hall will be crowded with babbling throngs; the dining room will resound with multitudinous knives and forks; the waiters will skip about in lively fashion; the hum-drum of Summer will yield to the hurly-burly of Fall and Winter." Mr. John Goldstein was the assistant manager. "He is true to Faderland in his love for the meerschaum, and true to every responsibility, we dare avow. We sincerely trust that the coming season will bring unlimited guests to the good old house, and an infinite amount of currency to the pockets of its whole-souled proprietor." (Photographer: J.A. Palmer.)

A contemporary note on the back of this image reads: "Original state house of Georgia in Augusta. Now torn down—1873." The building was located at the site of 209 McIntosh Street (7th) on the east side. This view was taken from Usher's Studio across the street on the southwest corner of Broad and McIntosh Streets around 1872. A Chronicle article dated October 9, 1899 titled "Reminiscences of Augusta" includes in part, the following: "Another structure that ought to have been preserved for the associations connected with its history and uses, was the brick building that stood on the east side of McIntosh Street, facing the Post Office. Its high-peaked, gable front—. In that building was convened the first legislature of the state of Georgia, in 1779 and at various other periods thereafter." The building is also mentioned in a Chronicle article dated January 16, 1874, but nothing is mentioned in regard to the legislature meeting there. A Chronicle article from July 24, 1960 by Edith Bell Love tells of the research done by the late Morton Reese, who believed the old building was the statehouse, but could not prove it before he died. (Photographer: John Usher Jr.)

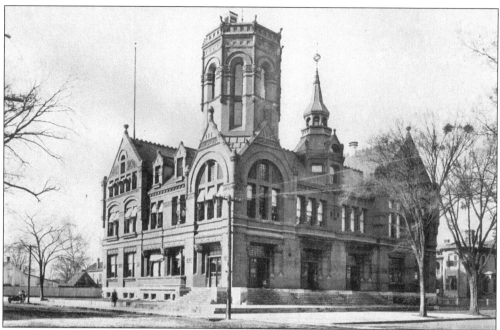

Augusta got a new post office costing $150,000 in 1888. It was located on the southwest corner of Greene Street and Campbell Street (9th). The architecture was of the Romanesque style. It was completed, except for a heating system, in 1890. The heating system was installed in 1891. Postal receipts in 1891 amounted to over $66,500. When construction started in July of 1888 the government contractor hired haul wagons without getting license tags. All the drivers were promptly arrested and taken to city hall and charged. The *Chronicle* wrote on July 24, 1888: "Uncle Sam's carts needn't suppose they can drive over an Augusta ordinance." The building was demolished in 1958. The Augusta-Richmond County Library building occupies the site today. (*Art Work of Augusta*, W.H. Parish Publishing Company, Chicago, 1894; courtesy Augusta Museum of History.)

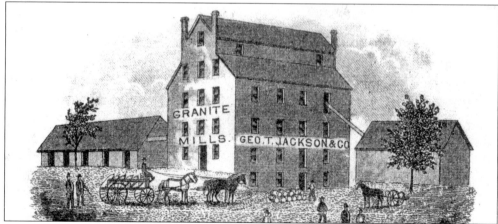

George T. Jackson & Company's Granite Mills were located on Kollock Street (11th) south of Telfair Street between the second and third levels of the canal. The mill can be seen in this photograph taken around 1878. Their "Gold Medal" brand flour was a popular commodity. The name was later changed to Excelsior Mills. J.M. Berry was the proprietor by 1888. The building no longer exists. (Courtesy Augusta Museum of History.)

The courthouse, more commonly known as the Richmond County Courthouse, was built around 1820 in the Adamesque-Federal style. It was located on the south side of Greene Street halfway between Centre Street (5th) and Washington Street (6th). This picture was taken around 1874 by John Usher Jr.

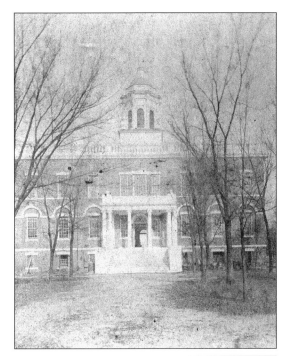

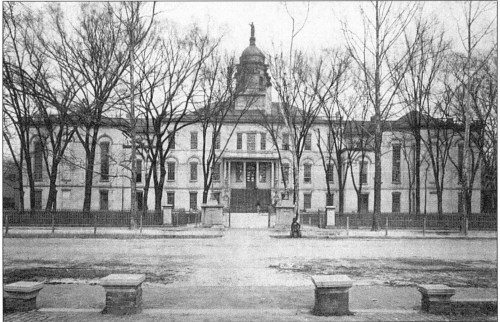

The courthouse as it appeared in 1900 is visible showing the wings added on each side of it in the early 1890s. A story in the *Augusta Herald* on September 22, 1940 stated that bricks from the second lower market that was torn down in 1892 were used in the construction of the courthouse wings. It also stated that the old market clock was placed in the belfry of the courthouse. The courthouse was replaced by the current Augusta-Richmond County Municipal Building in 1957. (Published by A.F. Pendleton, Bookseller and Stationer, Augusta, GA. The Albertype Co., N.Y.)

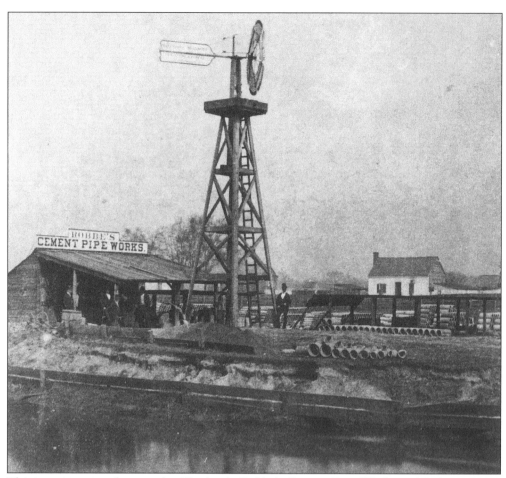

This is a rare view showing the Charles A. Robbe's Cement Pipe Works on McKinne Street (13th) between the second level of the canal and Walker Street around 1885. The house in the background is on Walker Street. The view is looking north. An advertisement for "Halladay's Standard, U.S. Wind Eng. & Plumb. Company. C.A. Robbe, Agt." is painted on the fin of the windmill. Robbe was also a dealer in plumbing, steam, and gas fittings. He was elected mayor of Augusta, upon the death of the incumbent, in April 1899, and died in office in July 1900. The Augusta Plant of American Concrete occupies the site today.

An 1872 C.A. Robbe billhead lists many of his business activities. He was also elected chief of the volunteer fire department from 1876 until 1879. (Courtesy Augusta Museum of History.)

The handwritten title on the back of this image says "Cracker Cart, Selling Chairs." The picture is a recent acquisition. It is difficult to determine the exact location of the scene. A city ordinance required peddlers to purchase a license before selling their wares on the streets of Augusta. Also written on the back of this picture is the name "Sarah J. Hall, 1879." She was the widow of B.F. Hall, former planter and Augusta postmaster. (Photographer: John Usher Jr.)

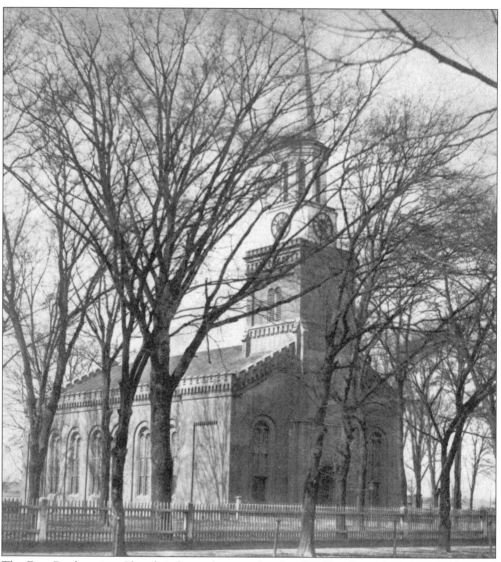

The First Presbyterian Church is located on south side of Telfair Street between Washington (6th) and McIntosh Streets (7th). This photograph was taken around 1873. The building was constructed between 1809 and 1812. The steeple was added in 1818. Robert Mills designed the church in the Federal style, which is reflected in this view. The church was remodeled in the Romanesque style in 1892 and the clocks were removed. "The church is one the few antebellum locations that has maintained its picket fence intact" (*The Georgia Catalog, Historic American Buildings Survey, A Guide to the Architecture of the State* by John Linley, University of Georgia Press, Athens, GA). John Usher Jr. took the photograph.

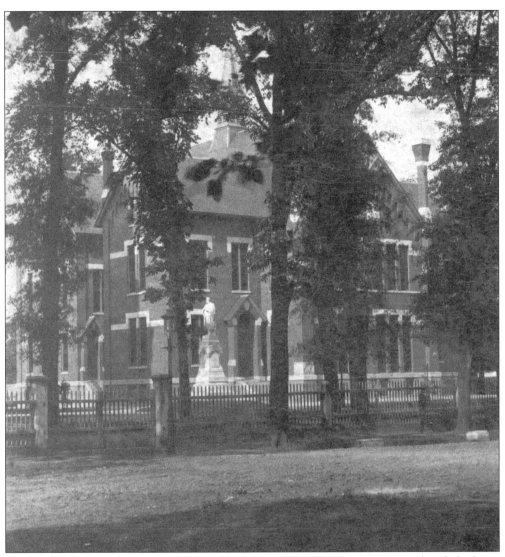

The Telfair Sunday School and Library building of the First Presbyterian Church had just recently been completed in this picture taken around 1885. Mr. Jacob Snyder, a church architect from Akron, OH, designed the building. The cornerstone was laid in September 1883. The building was dedicated with imposing ceremonies on June 22, 1884. The marble statue dedicated to Rev. Robert Irvine, DD, and erected in January 1884 by C.F. Kohlruss, can be seen in the center of the picture. The building is of the Gothic style with 96 windows and 150 gas burners for illumination. The central feature of the building was the large two-story Sunday school auditorium with two stories of radiating classrooms gathered in a semi-circle with a balcony in front of the rooms on the second tier. The Sunday school superintendent sitting on the first floor in the center of the semi-circle could keep his eye on every classroom. It was considered one of the finest and most complete Sunday school halls of its type. The M.L. Cormany took the photograph. (*Memorial History of Augusta, Georgia* by Charles C. Jones Jr., LL.D. and Salem Dutcher, D. Mason & Co., Publishers, 1890, The Reprint Company, Spartanburg, SC, July, 1966.)

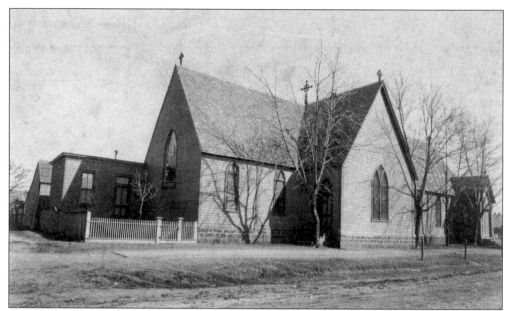

The Church of the Atonement on the southeast corner of Telfair Street at Cumming Street (10th) presents a strikingly different appearance from its final form after it was remodeled in the Carpenter-Gothic style at a later date. The building was designed by Edward Gardiner of Philadelphia and constructed by W.H. Goodrich of Augusta in 1850. It was torn down in 1976. (Courtesy Augusta Museum of History.)

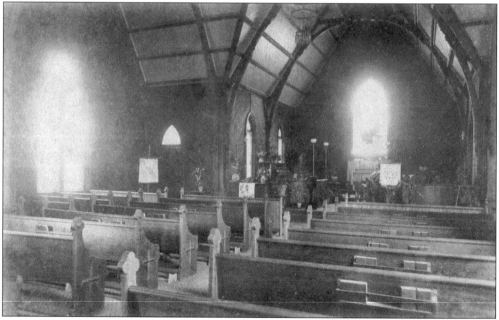

This rare interior view of the Church of the Atonement gives us a glimpse into some of the beauty and simplicity in Augusta architecture that has become extinct. Robert McKnight, the author's great-grandfather, joined the church in June 1853. The author's grandparents, Mattie Anne McKnight and Joseph M. Lee, were married at this church on May 6, 1896. (Courtesy Augusta Museum of History.)

This is a bird's-eye view from the fire-alarm bell tower looking southwest over the First Baptist Church building toward the Augusta Factory. The water tank on Cumming Street (10th) at Fenwick Street can be seen in the background. The First Baptist building in the photograph was constructed between 1820 and 1821. A new building, which still stands, replaced the old building in 1903. The church moved to a new location at 3500 Walton Way Extension in 1975. The house next door to the church building at 814–816 Greene Street was a three-story duplex brick dwelling. The old First Baptist Church Educational Building occupies the site today. (Photographer: John Usher Jr.)

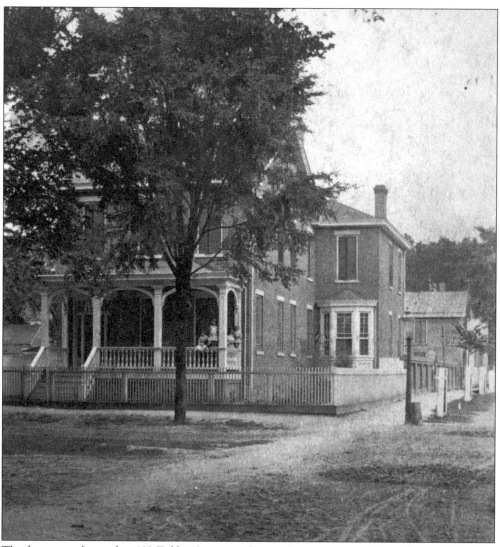

This house was located at 403 Telfair Street on the northwest corner at Elbert Street (4th). The picture was taken around 1874, very soon after William J. Rutherford had the house built. He probably commissioned the photographer to take the stereo view in order to show off his new home. Rutherford owned a brickyard and undoubtedly used his own bricks. What better way to advertise! The house still exists today. (Photographer: John Usher Jr.)

This Italianate-style house was the residence of Col. James Gardner who named it "Ingleside." The photograph was taken around 1875 by J.A. Palmer. Gardner was the owner of the *Augusta Constitutionalist* newspaper that was a competitor of the *Augusta Chronicle*. The house was located in Harrisonville on Wrightsboro Road across from where Druid Park Avenue intersects Wrightsboro Road. The Sweetheart Company plant now occupies the site. (Research courtesy Erick D. Montgomery.)

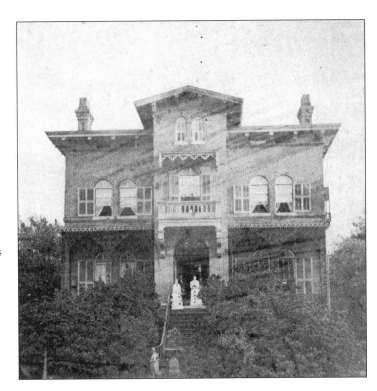

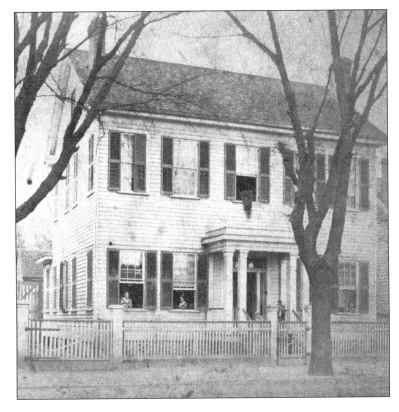

This stereo view of a Greek Revival-style house, taken in Augusta around 1873, is a recent acquisition and its location has not been identified through research efforts as of yet. (Photographer: John Usher Jr.)

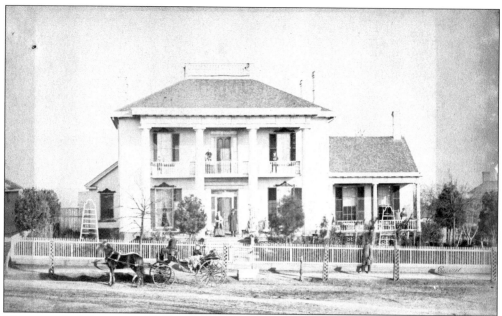

The original of this unique photograph is 11.5 by 9 inches. It was taken by Alphonse Pasquet. His studio was in a building between 714 and 720 Broad Street. He was only listed in the city directories in 1867. The exact location of this Greek Revival-style house in Augusta has not been determined. The carriage in front is a full-size calash, an expensive carriage costing $700 to $900 in 1860.

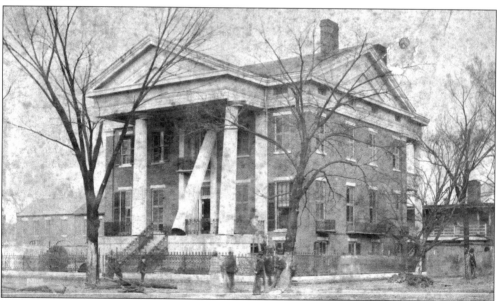

The Lower Market was not the only structure damaged by the cyclone on February 8, 1878. The Turner Clanton House at 503 Greene Street on the northwest corner at Centre Street (5th) was also hit by the storm, as evidenced by the damaged porch column. In the early 1900s this was the home and office of Dr. Thomas D. Coleman, a physician and surgeon. Later it housed the Richmond County Board of Health. It was torn down in 1956 and an office building was constructed on the site. (Courtesy Augusta Museum of History.)

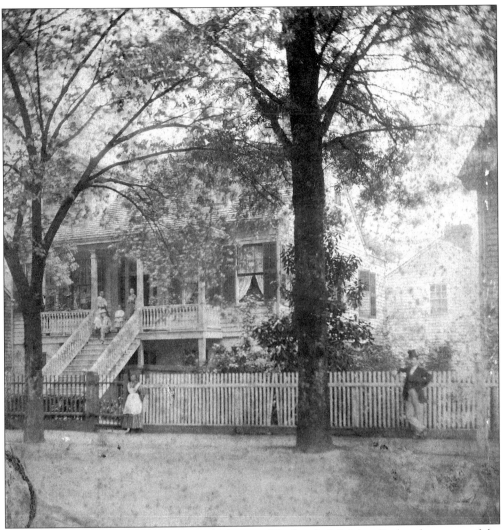

"Villa Brahe" at 456 Telfair Street was the home of Frederick Adolphus Brahe, the owner of the F.A. Brahe Jewelry Store at 702 Broad Street (see pp. 18 and 60). The house was constructed in 1850 as described in the "Bill of Specifications of a House of F.A. Brahe" drawn up in March of 1850. It is an example of the Sand Hills Cottage architecture in the Greek Revival style. The full English basement makes the house a unique structure to this part of town. All other houses of the period in this area were of the more traditional townhouse construction. The house remained in the same family until the 1960s. It is now a private law office. This information was extracted from Historic Augusta, Inc. files. (Courtesy Augusta Museum of History.)

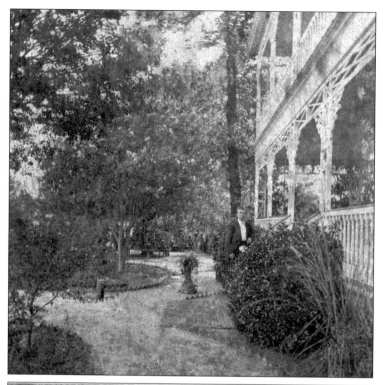

These two images of a plantation house with its landscaped yard and divided driveway have no identifying data except that they are thought to be associated with the Schley and Butt families. They could possibly have been taken at the home of Gov. William Schley at Richmond Hill or at the home of his brother, John Schley (or Shly, as he spelled his name), at Bellville or DeBruce. (Photographer: John Usher Jr.)

This view is titled simply "Natural curiosity, deformed Mulberry tree" and was taken around 1873. *Appleton's Journal* featured an article on Augusta in September 1871 that included an illustration of a deformed mulberry tree on the riverbank. The *Chronicle* did not like it and said so in an article dated September 15, 1871: "It's (the sketch) most conspicuous feature is an impossible mulberry tree, with surroundings equally unnatural and absurd." (Photographer: John Usher Jr.)

An alligator (stuffed?) poses for the photographer at Moore's Lagoon adjacent to Lover's Lane, south of Sand Bar Ferry Road. (Photographer: John Usher Jr.)

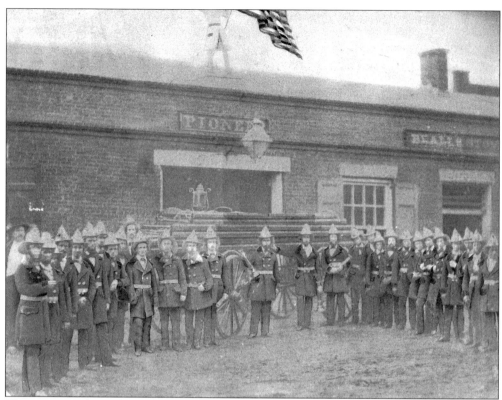

This rare view shows the Volunteer Fire Department Pioneer Hook and Ladder Company No. 1 in the 1850s. The company was organized in 1854. (Courtesy Augusta Museum of History.)

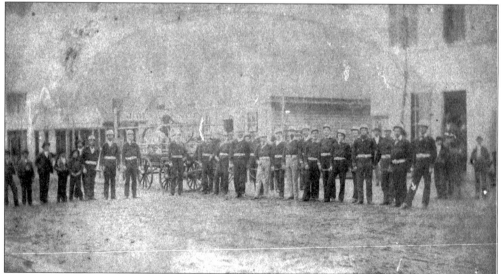

This rare view is titled "Richmond Fire Company No. 7 (Hose), 909 Telfair Street (1880), Volunteer Days." The location of the station was just west of Campbell Street (9th). In 1884 Richmond No. 7 moved into a beautiful new fire station at the southeast corner of Campbell and D'Antignac Streets. The building still exists at the northwest corner of Dyess Park. (Courtesy Augusta Museum of History.)

Miss Winnie May Owen strikes a jaunty pose for the photographer around 1879. She wears a dress made from a dark dotted fabric with bias bands on the skirt, a wide white collar, and a sash at the waist. Her bold striped stockings were fashionable for children and she completes her costume with high-buttoned shoes. Winnie May Owen married C.L. Duvall on May 15, 1890. (Courtesy Augusta Museum of History.)

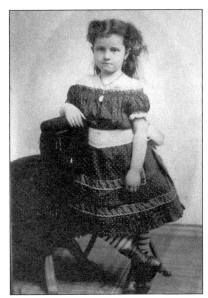

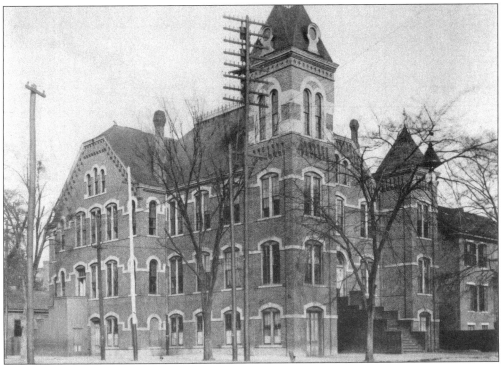

Central Grammar School was built on the northeast corner of Telfair and McIntosh Streets around 1888. School superintendent Lawton B. Evans designed the three-story brick building. The school featured separate staircases for boys and girls. There was no standing allowed in the halls. Pupils were marched in and out, up and down "in regular military line and discipline." In World War II it was used as a vocational training school for the war industry. The building was sold in 1951 and it no longer exists (*The Quest: A History of Public Education in Richmond County, Georgia* by Edward J. Cashin, Augusta, GA, 1985; *Art Work of Augusta*, The W.H. Parish Publishing Company, 1894). (Courtesy Augusta Museum of History.)

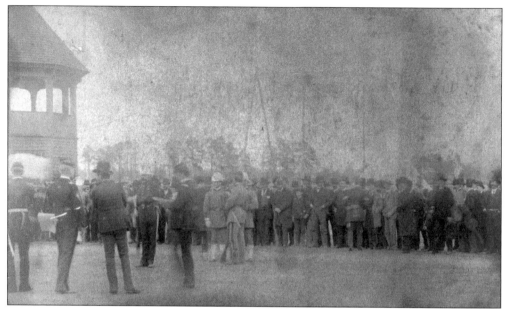

This is a rare view at the Augusta National Exposition, held between November 8 and 15, 1888. Men dressed in military uniforms stand out front. A crowd waits in the background for some event to take place. (Photographed by the Augusta Art Gallery.)

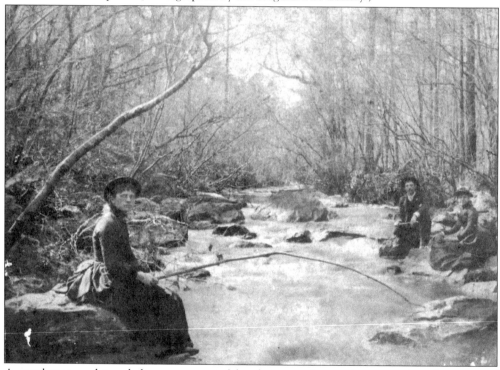

A gentleman and two ladies accompanied by their two dogs enjoy an outing along one of Augusta's waterways around 1889. Michael White has tentatively identified the location as the rapids on Rae's Creek near what is now the Augusta National Golf Course. (Photographed by the Augusta Photo Company.)

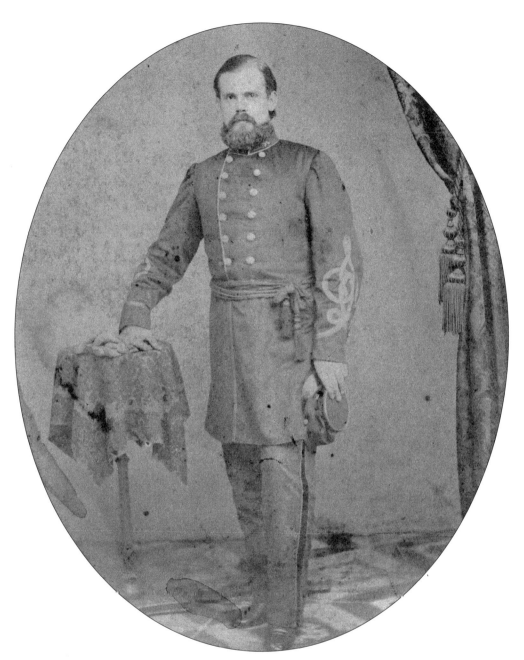

This is an outstanding view of John Scott Coleman, a surgeon for the Confederate States of America, taken in February 1862. "Early in 1864, the northeastern end of the warehouse building at the arsenal on the Hill was converted to a hospital for gangrene cases under Acting Surgeon John S. Coleman." (*Confederate City, Augusta, Georgia 1860–1865* by Florence Fleming Corley, University of South Carolina Press, Columbia, SC, 1960). In 1872 Coleman was listed in the city directory as a physician and demonstrator of anatomy at the Medical College of Georgia. He was physician in Augusta until he died on June 19, 1892. (Courtesy Augusta Museum of History.)

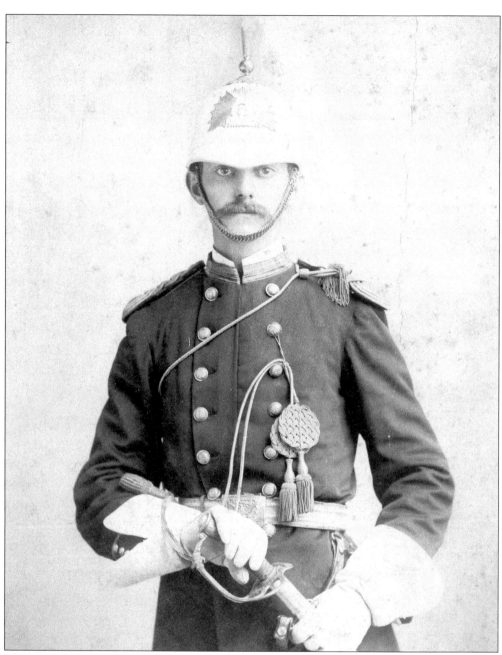

An outstanding 1890 view of First Lt. Robert C. Berckmans in his Richmond Hussars uniform holding his model 1872 U.S. Army calvary officers dress sword. The *Richmond Hussars Centennial Booklet, 1795–1895* carried this description of Lieutenant Berckmans: "Lieutenant Berckmans was elected to his position in 1890. He is a good officer and popular with the men. He is very energetic and does a great deal to keep up the interest in the Troop. He received a military education at Bingham's Military School in North Carolina. He is one of the oldest active members of the Troop, and he gained his present position by hard work and active interest. Lieutenant Berckmans was appointed assistant instructor of rifle practice at the last State Encampment for the Cavalry." (Courtesy Augusta Museum of History.)

This stately gentleman is the Reverend Stephen Elliott Jr., the first Episcopal Bishop of Georgia from 1840 to 1866. He died on December 26, 1866 at his home in Savannah a short time after this photograph was taken. (Photographer: J.W. Perkins.)

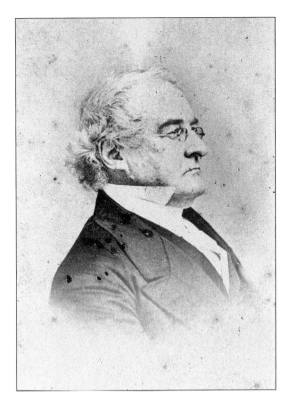

A pretty young miss holding her puppy stands resolutely for the photographer around 1865. She is dressed in a short-skirted checkered dress that is trimmed with two thin bands of colored ribbon. The dress is topped by a white collar and she wears pantalettes and ankle boots common for the era. (Photographer: J.W. Perkins.)

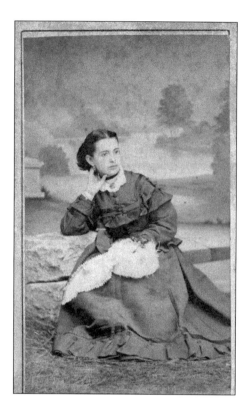

Josie Hack was the daughter of Daniel DeBruce Hack. In the September 7, 1873 *Chronicle* he was included in a list of people paying taxes on $10,000 and up. Josephine A. Hack and Hansford A. Duncan Jr., an attorney, were married October 24, 1872. The photograph was taken a few years later by Pelot & Cole. (Courtesy Augusta Museum of History.)

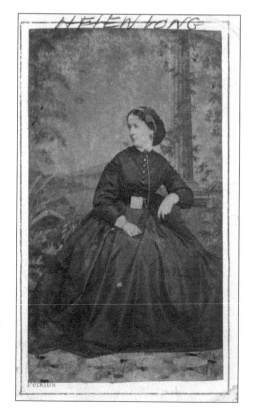

Penned on the reverse of this photograph is the following: "Cousin Helen Long. Papa's 1st Cousin. She was considered the prettiest woman that walked the streets of Augusta, Ga., also of Baltimore, Md. Her father owned the largest dry goods store in Augusta during the Civil War. Ellis Long Dry Good Co." During the period Ellis contributed money to the Second Georgia Hospital and to the establishment of a soup house for the poor and hungry. This picture was taken around 1866 by J.W. Perkins. (Courtesy Augusta Museum of History.)

This Cartes de Visite of Augustus R. Bohler was taken in Augusta in 1864. Shortly afterwards he was killed and his wife, Almyra S. Reab, placed this epitaph on his tombstone in the Walker Cemetery at the Augusta Arsenal (Now Augusta State University): "A tribute of appreciation to my beloved husband Augustus R. Bohler who fell by a deadly weapon in the hands of an enemy in Augusta, Georgia, May 1st, 1865 aged 28 years. Peace to his ashes. Night falls but soon the morning light its glories shall restore, and Thus the eyes that sleep in death shall wake to close no more." (Photographer: George J. Gable.)

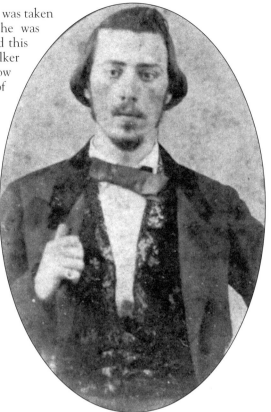

This young Augustan woman was lamenting a loss when she penned this rhyme on the back of her photograph around 1887: "Is it rain in life's wide sea, to ask you to remember me? Undoubtedly it is my lot, just to be known and then forgot." (Photographers: Bassett & Payne.)

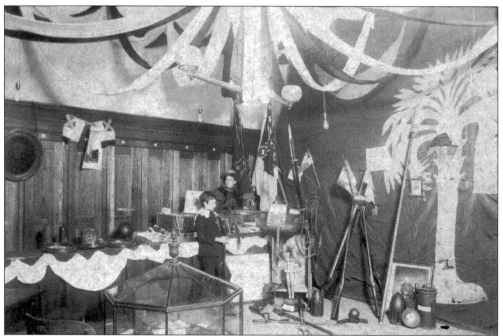

This outstanding historical image shows the interior of the Confederate Museum at the Confederate Survivors Fair held in Augusta, between April 22 and May 1, 1897. Civil War relics on display included rifles, revolvers, swords, a John Brown pike, cannon shells, military accoutrements, and flags among other items. The large flag on the wall to the right is the South Carolina flag that floated over Fort Moultrie during the bombardment of Fort Sumter in 1861. (Courtesy Augusta Museum of History.)

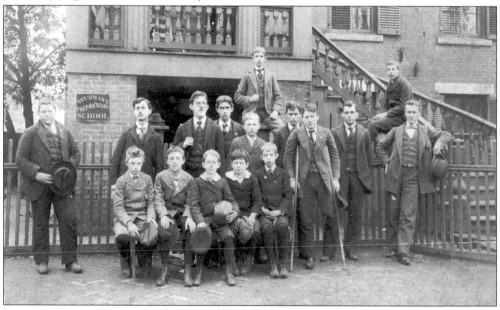

The Sturman Preparatory School was located at 846 Greene Street in 1896 when this photograph was taken. William H. Sturman was the principal. The building no longer exists. (Courtesy Augusta Museum of History.)

The quotation on the announcement for closing exercises at Tubman High School on June 26, 1888, says it all: "Duty is Heaven begun; and Heaven's whole happiness is Duty!" The graduating class students are named by number: 1. Kate Hill, 2. Louise Schneiker, 3. Ruby Verdery, 4. Annie Seago, 5. Gertrude Stone, 6. Rebecca Duval, 7. Adele Pritchard, 8. Katie Black, 9. Mamie Saxon, 10. Albertina Brenner, 11. Ella Evans, 12. Pauline Brahe, 13. Kate Wylds, 14. Jennie Chapman, 15. unknown, 16. Marie Carr, 17. Celeste Walton, 18. Mary Meyer, 19. Ruth Weigle, 20. Pauline Harker, 21. Professor John Neely, 22. Jennie LaFitte, 23. Maggie Johnston, 24. Fannie B. Keener, 25. Lizzie Lee Burwell, 26. Elise Gibbs, 27. Rachel Reid, 28. Jeanette Burns, and 29. Hattie Miller. (Courtesy Augusta Museum of History.)

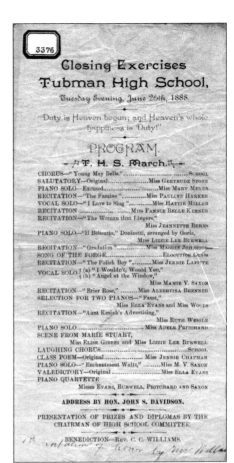

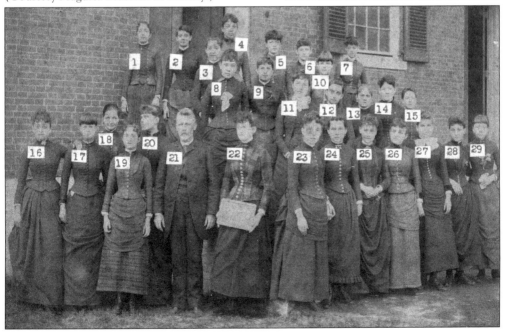

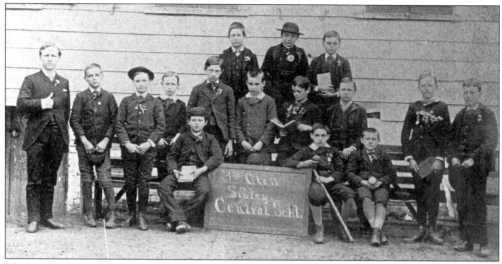

The sign announces the 1st Class, Sibley Central School, in 1885. The Second Ward Sibley Grammar School was located at 743 Greene Street just east of Jackson Street (8th) on the north side. Shown here, from left to right, are the following: (front row) G. Ransom, T. Butler, A. Martin, J. Walker, C. Rowland, W. Wallace, and L. Sibley; (middle row) V. Richards, L. Freeland, B. Crane, R. Rutherford, and M. Plumb; (back row) J. Sare, unidentified, C. Evans, and D. Macmurphy. The photographer of this picture was George R. Tommins. (Courtesy Augusta Museum of History.)

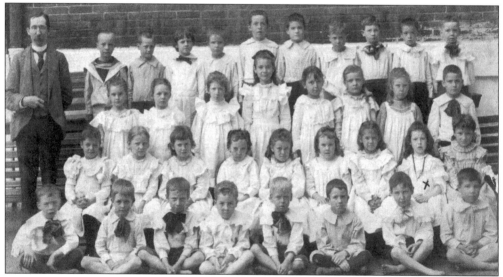

The Houghton Grammar School Class of 1899 is featured in this picture. Shown here, from left to right, are the following: (front row) Jessie Irvin, Wallace Barnes, Milton Williams, Cortez Goodrich, Edward Evans, Clarence Dasher, Dunbar Otis, and Robert Parks; (second row) Margie Clark, Madelle Stucker, Bertha Bohler, Madelle Hutto, Addie Plumb, Ruby Walton, Elida Morris, Alberta Gehrken, and Minnie Lou German; (third row) Pauline Sibley, Christina Mohrman, Mary Porter, Essie May Wilson, Annie Dora Schmidt, Josie Schweringen, Evelyn Hubert, and Marion Parker; (fourth row) Mr. Algernon F. Otis, Principal, Clayton Boardman, Joe Miller, Clifford Dawson, Ollie Price, James Ward, Paul Stevens, George Starr, Julian Stoy, Fred Speering, and Walter Gehrken. (Courtesy Augusta Museum of History.)

Four
WATER AND STEAM

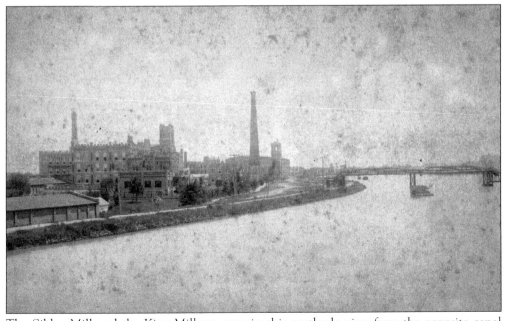

The Sibley Mill and the King Mill are seen in this southerly view from the opposite canal bank around 1890. The building in the left foreground is the office and warehouse of the Algernon Mill that is just off to the left of the area this image captures. (Photographed by the Augusta Art Gallery.)

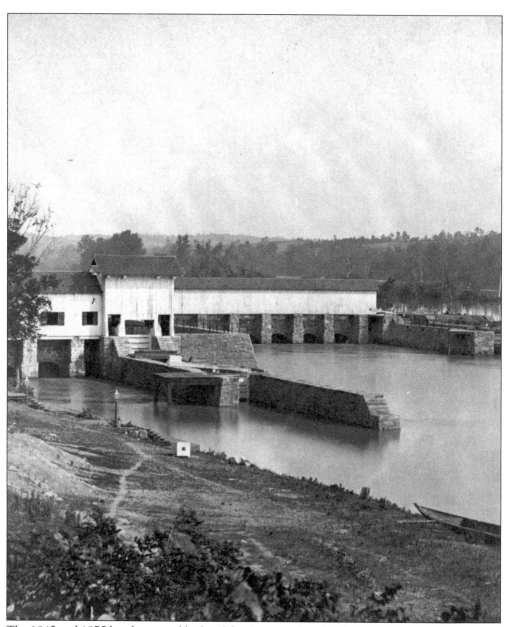

The 1845 and 1875 headgates and locks of the Augusta Canal as they appeared around 1880 are shown here. The structures on the left-hand side are the 1845 headgates and lock. The structures further back on the right-hand side are the headgates and lock from the 1875 enlargement. On the left hand side of the image there is a wood walkway and steps going down to a barely visible dock. There are gaslights at each end of the dock for nighttime illumination. A small section of a Petersburg boat pulled up onto the bank is visible at the right-hand edge of the image. (Photographer: J.A. Palmer.)

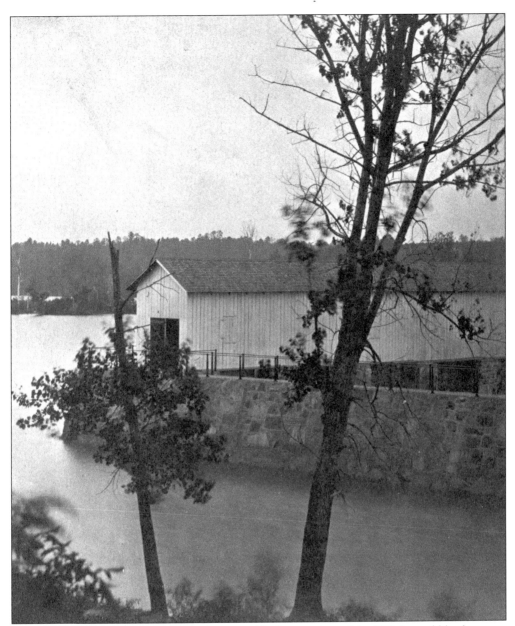

The backwater of the 1845 canal headgates and lock, a portion of the 225-foot rubble abutment that runs from the 1845 headgates and lock to the 1875 headgates, and the structure covering the 1875 headgate lift gate mechanisms are visible here. The backwater area was filled in at some point in the 1970s. The Augusta Canal National Heritage Area Master Plan calls for the backwater area to be restored along with the 1845 headgates and reopened lock. (Photographer: J.A. Palmer.)

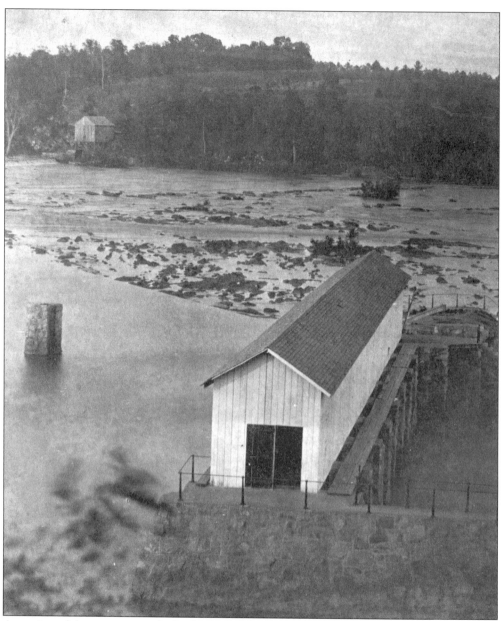

A portion of the entrance to the backwater of the 1845 canal headgates and lock and the 1875 canal headgates and lock can be seen in this view. In addition the Bull Sluice area of the river can be seen along with the 1875 dam built to create a pool and slight diversion to direct the river towards the canal gates. Information for the three canal images was extracted from Augusta Canal Authority publications. (Photographer: J.A. Palmer.)

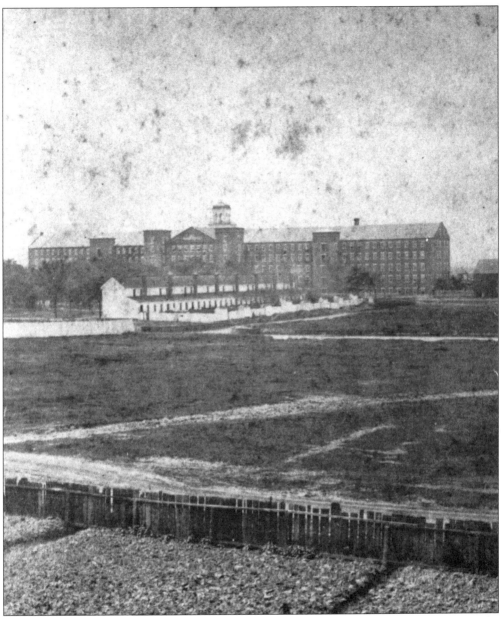

This southward view of the Augusta Factory was taken around 1875 from the roof of the Augusta and Summerville Railway shop building on McKinne Street (13th) just south of Greene Street. The row of buildings in the center of the image are mill houses fronting on Perkins Park and bounded by Marbury Street (12th), McKinne Street (13th), Fenwick Street, and Canal Street. A wall surrounds the area behind the houses. Looking along the wall parallel to the houses you will see small individual buildings. They are the privies. The raceway from the Augusta Factory on the first level of the canal runs parallel to the wall behind the privies down to the second level of the canal. The second level of the canal is visible running across the center of the image from right to left just below the mill houses. The road on the other side of the fence in the foreground is Walker Street. The Augusta Factory was torn down in 1961. (Photographer: John Usher Jr.)

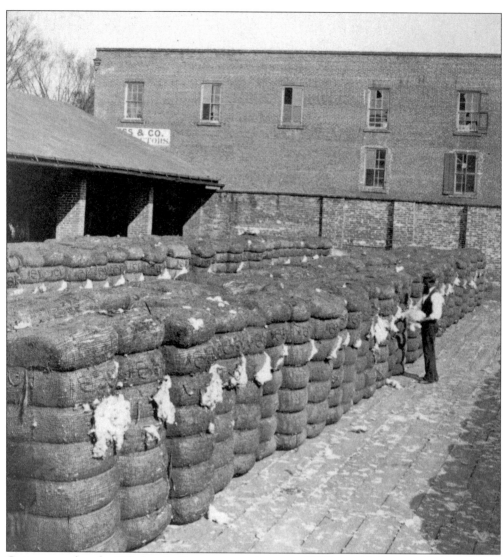

Cotton stored at the Wheless & Company warehouse at 727 Reynolds Street is being sampled by an employee around 1882. William T. Wheless and Edward T. Yarbrough were cotton factors and commission merchants. Early in the morning on a very cold January 3, 1884, a fire broke out in the Phinizy & Company cotton warehouse on Jackson Street (8th) across the street from Wheless & Company. The fire was brought under control after several hours but at that moment a wall collapsed. Embers flew across the street and ignited cotton at Wheless & Company. The fire spread rapidly, burning the roof off the east side of the warehouse, but the firemen got the fire under control, saving most of the cotton and the north warehouse. The loss on the Wheless warehouse was about $20,000 (*Chronicle*, January 3, 1884, and January 4, 1884). The photograph was taken by John Usher Jr.

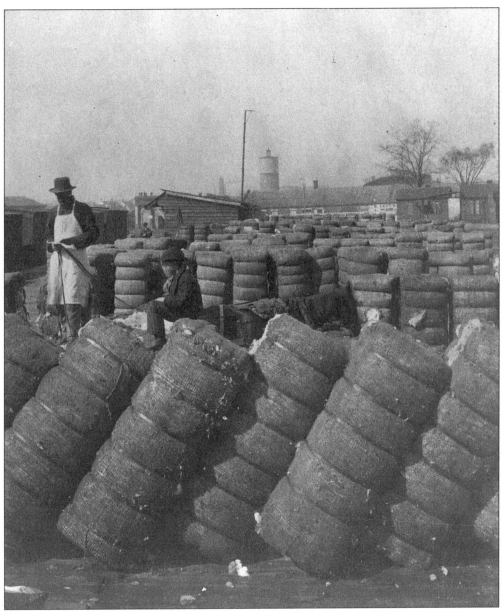

Cotton is stored on the Georgia Railroad cotton yard platform on Walker Street, between McIntosh Street (7th) and Jackson Street (8th), before being shipped to its final destination. The view is looking west across Jackson from a spot near the intersection of Walker and McIntosh. The building in the background with the long roof line is the Georgia Railroad oil house and tin shop that was positioned parallel to Jackson Street. The water tank on Cumming Street (10th) at Fenwick Street (p. 55) can be seen over the top of the oil house and tin shop building. John Usher Jr. took this photograph around 1880.

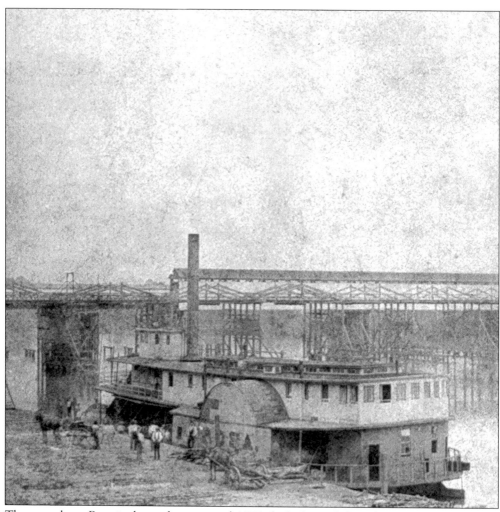

The steamboat *Rosa* is shown here around 1873 docked just below the Centre Street (5th) bridge. Competition from the railroads for hauling cotton had dramatically reduced steamboat traffic between Augusta and Savannah by the 1870s. Ruby A. Rahn in her book *River Highway for Trade, The Savannah* (published by the Georgia Salzburger Society) stated that by the 1870s only the *Rosa* and the *Katie* maintained regular service between Augusta and Savannah. The 975-foot-long Centre Street wood bridge to Hamburg, SC, can be seen in the background. Just beyond it is the covered South Carolina Railroad Bridge. The railroad was required to build a covered bridge in order to keep the smoke and noise from the engines from frightening the horses on the Centre Street bridge. (Photographer: John Usher Jr.)

Augusta was hit with an arctic wave of cold weather in January 1886. The temperature went down to six degrees above zero. The Savannah River was packed with ice floes. The canal was frozen and the fountain on lower Broad was frozen over about 3 inches thick. People went ice skating at Moore's Lagoon and on the lake at May Park. This image shows some of the ice in the Savannah River on January 11, 1886. (Photographer: M.L. Cormany.)

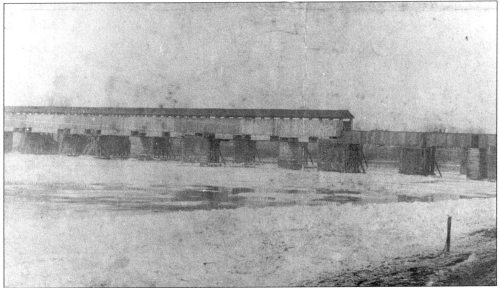

The South Carolina Railroad Bridge and the Centre Street (5th) bridge over the Savannah River are shown surrounded by ice in this image during the deep freeze in January 1886. The *Chronicle* made an appeal to help for the poor, the sick, and the cold. The community responded generously with money, clothing, food, and fuel. The *Chronicle* summed it up on January 12, 1886: "...when the sand beds lift their backs from the low waters and the stream shrivels into a narrow rivulet, we will tell our descendants how for two days in '86 the river was a moving snow fleet and around the bridges were great gorges of ice." (Courtesy Augusta Museum of History.)

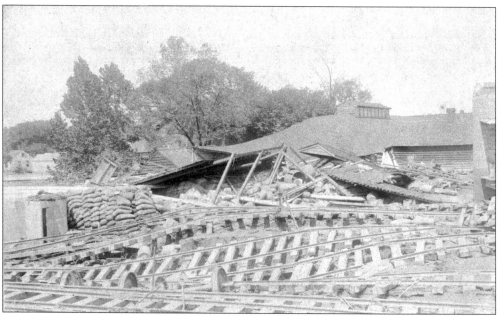

The wreckage of the rear of J.M. Berry's warehouse and the washed out Georgia Railroad tracks over the third level of the canal are shown in this westward view of the flood of September 10-11, 1888. Berry's warehouse was located at 932–934 Walker Street on the south side just west of Campbell Street (9th). The tracks crossed Campbell Street just south of Walker Street going into the old railroad depot and Georgia Railroad yards. There are several warehouses remaining on Walker Street at the site of Berry's warehouse. The Augusta Art Gallery took this photograph and the one below.

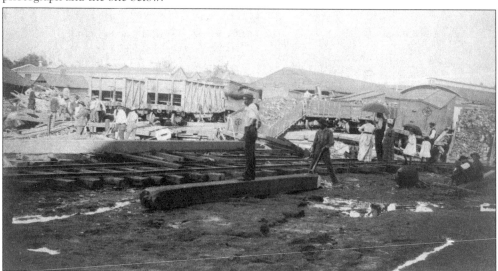

The photographer has moved his camera over to the west side of the third level of the canal and turned east to show more of the damage caused by the great flood of September 10-11, 1888. The end-gable building in the center is the Georgia Railroad car shed. The other end of the shed opens onto Campbell Street (9th). The rounded-arch gabled building in the background with the ventilating transom windows on the roof is the Georgia Railroad freight warehouse that was adjacent to the Union Depot on the south side.

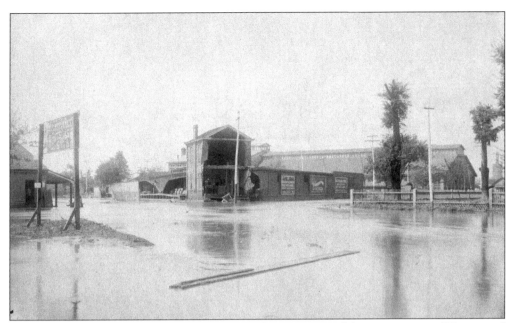

Lee & Bothwell's warehouse, located in the northwest corner of the intersection of Twiggs and Walker Streets, suffered extensive damage during the flood of September 10-11, 1888. This area was known as the Triangle Block. The antebellum fence surrounding the First Presbyterian Church can be seen on the right side. John C. Lee and James T. Bothwell were wholesale grocers. The site is now a portion of the parking lot for the Augusta-Richmond County Civic Center. (Photographed by the Augusta Art Gallery.)

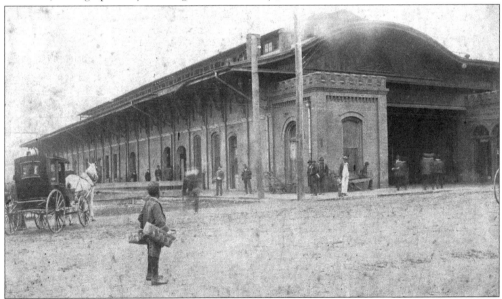

Augusta's Union Depot from just after the Civil War until 1902 stood at the southeast corner of Campbell (9th) and Walker Streets. This photograph was taken around 1880. The castellated tower in front of the building on the left was an office. The ticket office was directly behind inside the depot. The tower on the right was a restaurant and the waiting room was directly behind this inside the depot. (Courtesy Augusta Museum of History.)

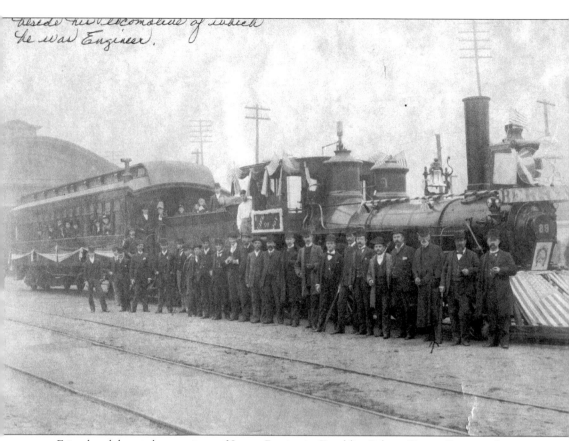

Friends celebrate the marriage of James Benjamin Franklin Sale to Emma Berry in this unique photo showing them gathered around the decorated Georgia Railroad engine of which he was the engineer in the early 1890s. Sale was known to his friends as Capt. Frank Sale. He died on June 8, 1899, at the age of 66. The funeral service was held at the Christian Church and he was buried in the City Cemetery (Magnolia Cemetery) on June 10, 1899.

Five
AFRICAN-AMERICAN LIFE

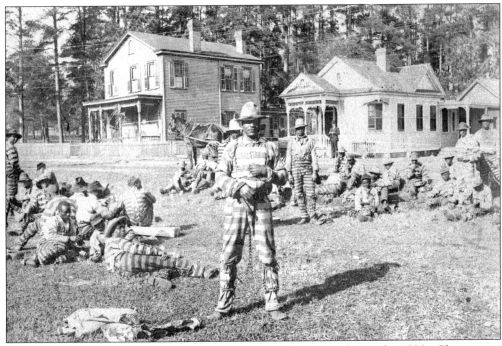

These convicts on the chain gang take a break on Walton Way during the 1890s. Chain gangs in the late 1800s and early 1900s worked under brutal conditions and endured unrequited abuse. They were hired out to businesses and individuals to perform the heaviest and dirtiest manual labor. Women were not exempt and also served time on the chain gang.

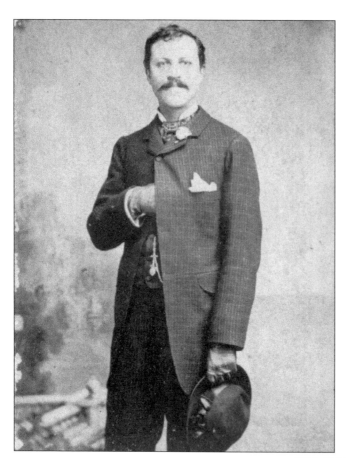

The man in this photograph, from a family album belonging to the late Evans M. "Chalky" Martin, was identified as Mr. Henry Osborne, Augusta's "first black harness maker." In the 1880s Osborne was listed in the city directories as a saddle and harnessmaker and dealer in shoe findings, collars, whips, and hames at the lowest prices. (Photographers: Pelot & Cole.)

This young African-American child poses stiffly for the photographer around 1892, while holding onto his (or her) hat. Young children of both sexes wore dresses to their ankles during this era. The photographer, Robert Williams, was Augusta's first successful African-American photographer.

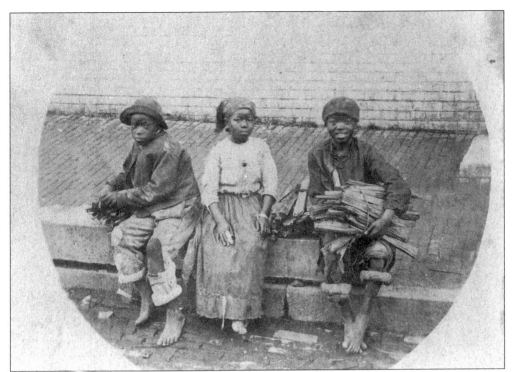

John Usher Jr. titled this stereo view taken around 1873 of three African-American children with their firewood, "Lightwood Merchants." *Appleton's Journal* in an article dated September 23, 1871, said that firewood was called "lightered" in the South. The usual price was 25¢ a bundle.

Henry Bennett, of Augusta, strikes a proud pose for his picture in his military uniform around 1896. Bennett worked as a plumber for P. McAuliffe & Son. There were six African-American military companies in Augusta at that time. This is a rare photograph as a short time later on April 24, 1899, the state adjutant general's office disbanded all the African-American companies in Augusta. (Photographed by Robert Williams & Son.)

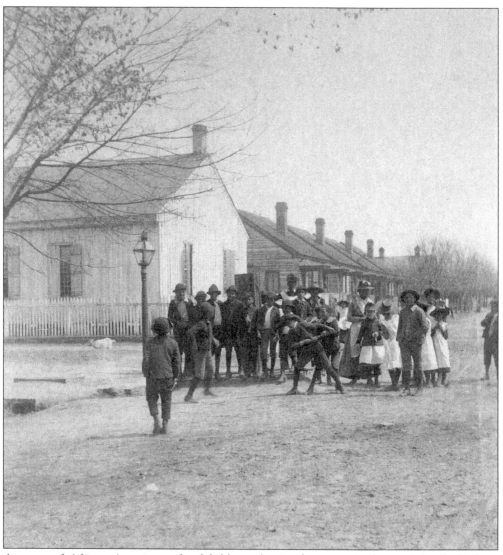

A group of African-American schoolchildren play in the street in front of the Bethlehem School on Brown Street just west of Augusta Avenue in the mid-1890s. Two boys in the center appear to be wrestling for a stick of some kind. The school building is gone but several of the houses in the background still exist. This view is looking west toward the railroad tracks that ran along Railroad Avenue, now R.A. Dent Boulevard. (Photographer: E.T. Gerry.)

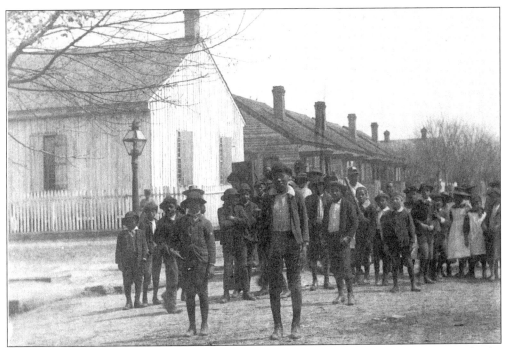

The same children strike poses for two more stereo views taken by E.T. Gerry who seemed to be enthralled with the group. The top view is looking west while the bottom view is looking south toward Wrightsboro Road. The Second Mt. Moriah Baptist Church now occupies the site of the school.

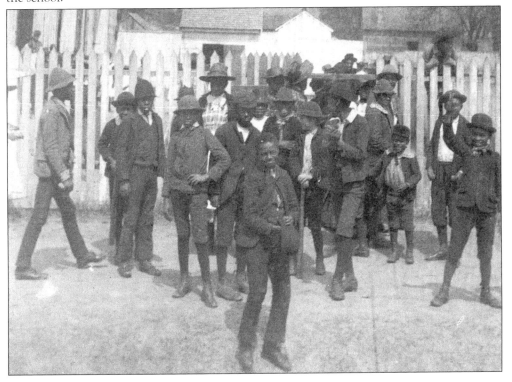

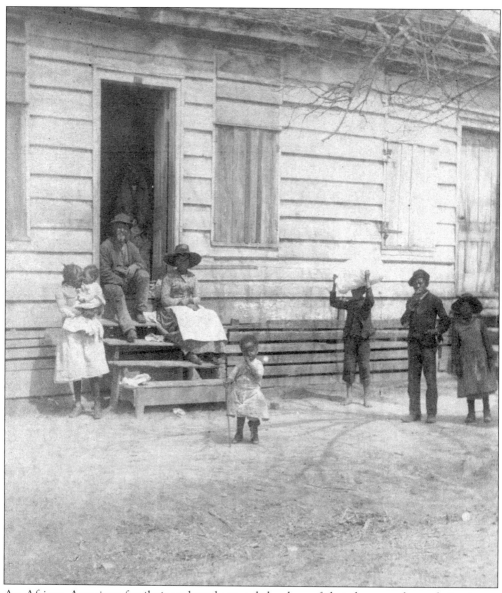

An African-American family is gathered around the door of their home to have their picture taken in the mid-1890s. During this period many African Americans lived in the southeast portion of the city. Depending on who is defining the boundaries, it is known more or less as the "The Terri" which is short for "The Territory." No location is specified on the stereo view, but the scene would be in context in "The Terri." (Photographer: E.T. Gerry.)

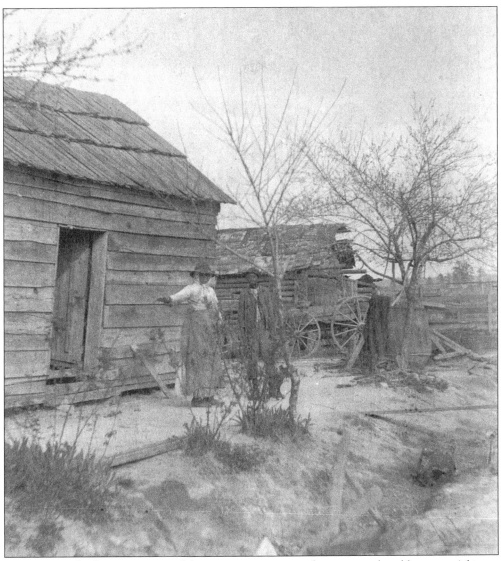

This view aptly illustrates some of the extreme measures of poverty endured by many African-American families in the last quarter of the 19th century. A lopsided shack beside a drainage ditch is all the shelter this family was able to afford. This scene probably took place on the outskirts of Augusta, possibly a sharecropper's home on a nearby farm. (Photographer: E.T. Gerry.)

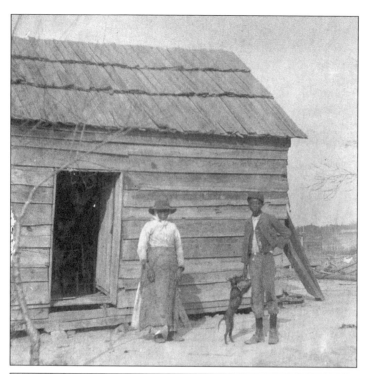

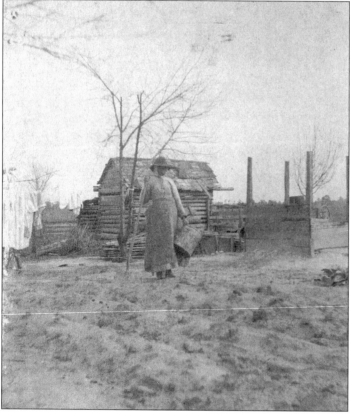

These types of shacks were typical of the dwellings of many of Augusta's African-American population during the late 1800s, especially those living on the outskirts of the city (*Augusta, A Pictorial History* by Helen Callahan, Donning Company/Publishers, Virginia Beach, VA, 1980). There are no amenities to be found in these images. The woman in the bottom view is apparently walking back to the house after hanging out the family laundry to dry. (Photographer: E.T. Gerry.)

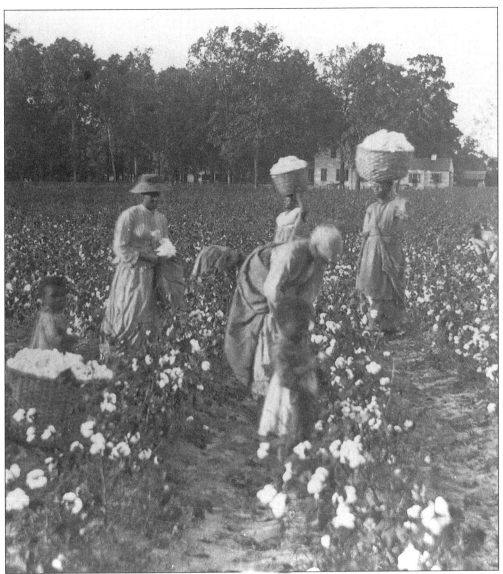

Cotton was a cash crop. Picking cotton was one of the few means African-American families had to earn more than a subsistence living, otherwise there were few opportunities for them to earn money in the countryside. The larger the family the more labor they had to work the cotton (*The Promise of the New South, Life After Reconstruction* by Edward L. Ayers, Oxford University Press, New York, 1992). (Photographer: J.A. Palmer.)

This unusual view shows a new grave in Cedar Grove Cemetery, an African-American resting place, surrounded by the bottles of medicine used during the last illness of the deceased in the mid-1890s. In the last quarter of the 19th century, "benevolent societies" were an important institution in African-American society. With their low wages they could not afford to pay for a serious illness or expensive funeral. By paying a small monthly fee to one of the "benevolent societies" a person would insure they had someone to help them with expenses during an illness or when death occurred (*The Terri, Augusta's Black Enclave* by Diane Harvey, Richmond County History, Volume 5, Number 2, Summer 1973). Mayor Robert H. May referred to the societies in his 1890 cemetery report reproduced on p. 48. (Photographer: E.T. Gerry.)

Six
SUMMERVILLE AND THE AUGUSTA ARSENAL

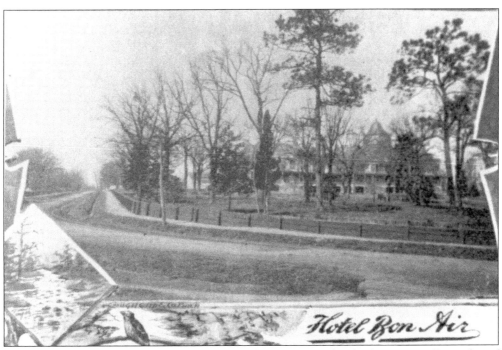

The Hotel Bon Air in Summerville opened its doors to guests for the first time in December of 1889. This scene, taken from a brochure advertising the 1891–92 season, shows the approach to the hotel from Walton Way at Telfair Street (Hickman Road). It was probably made for use in the first brochure in 1889 as there are no electric trolley line poles visible in the photograph. Electric operations did not began until May 1890.

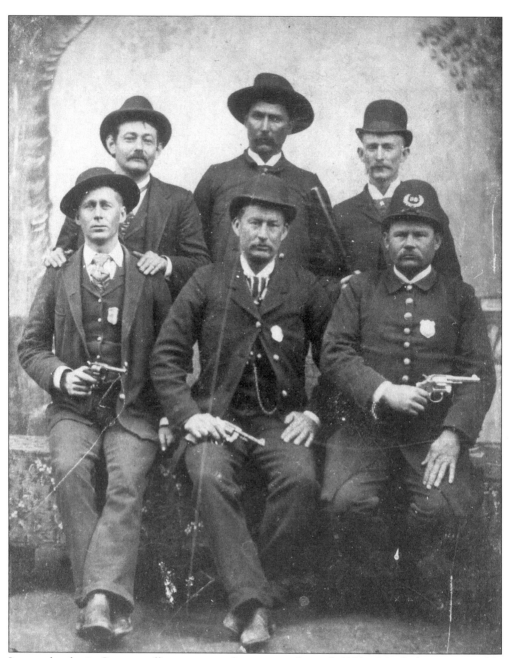

Law and order in Summerville was serious business in the mid-1890s. Marshal George Heckle (1849–1938), seated in the center, and some of his cronies are well prepared to handle their duties. Heckle was elected marshal in 1892 when the incumbent, Marshal Robert Harriss, was shot and killed as he intervened in a domestic dispute between Henry Ramsey and his wife. Heckle served as marshal, with the exception of the year 1900, until 1912, when Summerville was incorporated into the Augusta city limits. His marshal's report for 1897 listed 80 arrests for the year. Some elderly residents of Summerville interviewed in the 1970s recalled Heckle as a no-nonsense lawman that wore his pistol on his hip every time he left the house including Sunday. He was also remembered as a crack shot.

This photograph was taken by Joseph M. Lee III. It shows the badge that was worn by Heckle when he was marshal of Summerville. The badge is now in the possession of the author.

This Georgia Railroad account book saved Heckle's life during a gun battle on November 6, 1894. A riot between Populist and Democratic voters broke out at the 1269th district polling precinct on Battle Row. During the melee—in which two were killed, three were wounded, and numerous others were hurt by bricks and clubs—Heckle and a Populist named John Goss got into a shootout. Heckle was wounded in the side and his neck. Another bullet hit him in the chest but was stopped by the bankbook. Heckle survived his wounds, but his return fire fatally wounded Goss. His daughter, Mary Louise Heckle, who later became the author's grandmother, recalled seeing the large bruise on Heckle's chest as a result of the bullet striking the book. The book is now in possession of the author. (Courtesy Joseph M. Lee III.)

George Heckle married Sarah Atmar Rogers (1857–1927) in June 1877. They lived at 2471 McDowell Street most of their married life. In this photograph taken by L.N. Wade around 1879, Sarah is wearing an elaborate fringed necklace. The photograph was given to one of her siblings with the following note penned on the back: "A Merry Christmas and Happy New Year is the best wishes of your devoted sister. S.A.H."

In May 1883 seven-month-old Mary Louise Heckle (1882–1977), the daughter of George and Sarah Rogers Heckle, had her picture taken by M.L. Cormany. She married Dr. Orlin K. Fletcher in 1904 and lived at 2473 McDowell Street until she died in 1977.

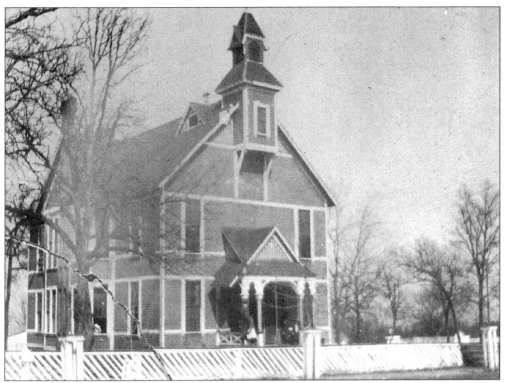

The Summerville Academy school building was located at 2357 William Street on the northeast corner of Katherine Street. Originally founded as the Hill branch of Richmond Academy, it eventually became a public school. The building was torn down in 1926 and William Robinson Grammar School was built on the site.

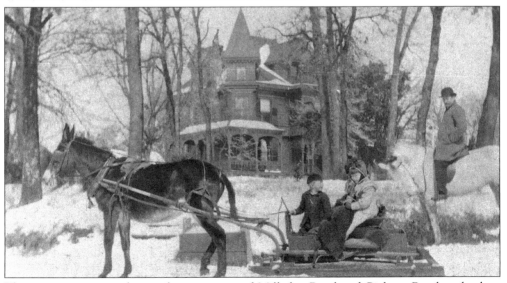

This wintry scene at the northwest corner of Milledge Road and Pickens Road took place around 1890. The J.P. Verdery house at 945 Milledge Road is in the background. The house still exists today. Ed Fruitticher, Stella Heckle, and Mary Lou Heckle are in the sled. George Heckle sits on his horse.

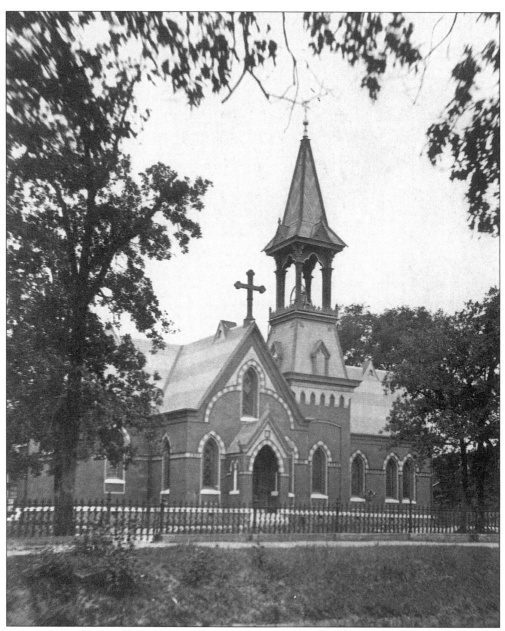

This is the second building erected by the Church of the Good Shepherd soon after it was completed. Designed in Gothic Revival style by architect John J. Nevitt, it was completed in 1880, replacing the original wooden structure. The church was located in Summerville on Walton Way between Milledge Road and Johns Road. On the morning of November 11, 1896, this building was destroyed by fire. Most of the furnishings were removed through the heroic efforts of nearby men and women who came to help when they heard the alarm. The walls of the church remained after the fire and they were utilized in rebuilding a new church building. The Church of the Good Shepherd is an important part of the Summerville community today. (Photographer: J.A. Palmer.)

Telfair Street in Summerville is deep in carriage and wagon ruts, in this photograph taken by J.A. Palmer around 1880, as it makes its way from Walton Way toward Heckle Street. Telfair Street was changed to Hickman Road when Summerville was incorporated into the city of Augusta in 1912. The fence on the right was in front of the Richard Heard home, which was called "Three Oaks."

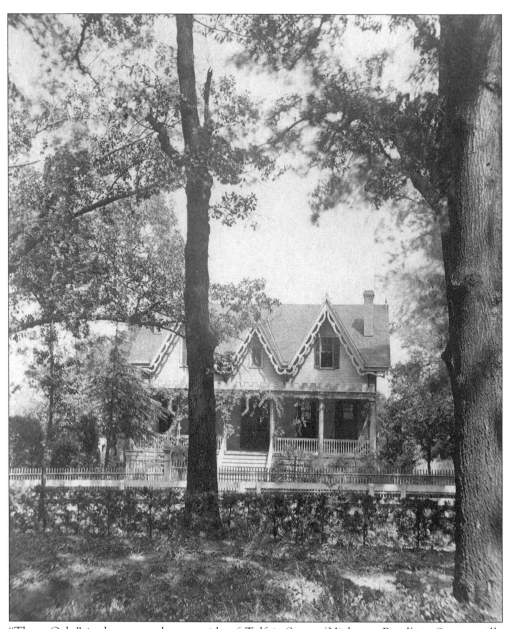

"Three Oaks" is shown on the east side of Telfair Street (Hickman Road) in Summerville around 1880. The site is now an apartment complex at 826 Hickman Road. Anna Platt Heard and her sister, Katherine Douglas Platt, took in boarders here in the late 1800s after the death of Anna's first husband Richard W. Heard in 1880. Anna and her sister "Katy" were among the founding families of the Church of the Good Shepherd (*Let the Hills Hear Thy Voice, a History of the Church of the Good Shepherd, Augusta, Georgia 1869–1994* by Victor A. Moore, M.D., The Reprint Company Publishers, Spartanburg, SC, 1995). (Photographer: J.A. Palmer.)

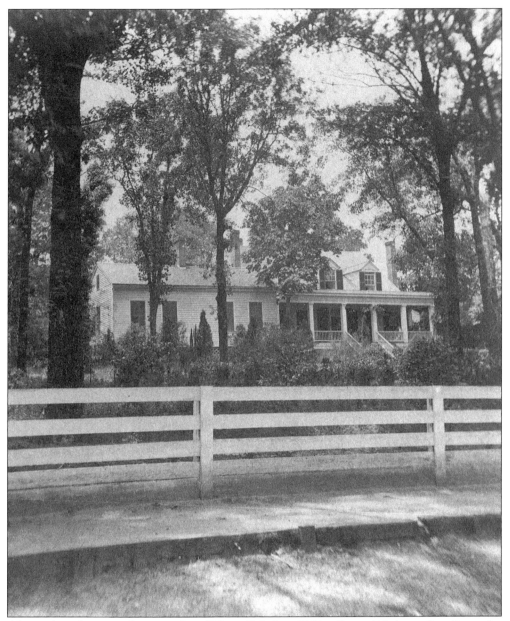

Almost directly across the street from "Three Oaks" on Telfair Street (Hickman Road) was the residence of Mrs. Edgar, the widow of J.S. Edgar. It was on the west side of Telfair Street just north of Cumming Street. The site is now the location of 817 Hickman Road. (Photographer: J.A. Palmer.)

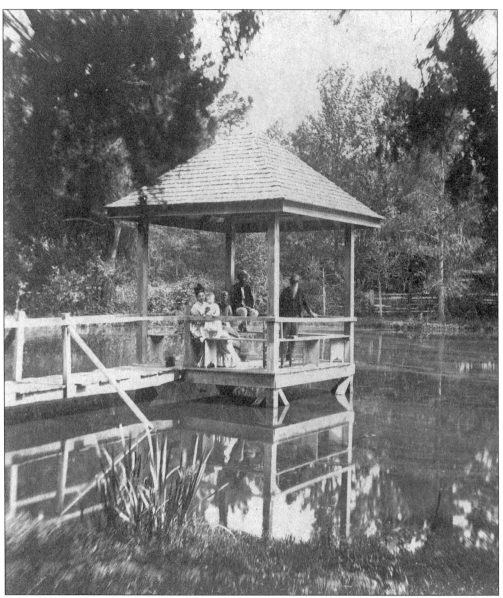

This pastoral scene captured around 1875, is on the site of what was known as Indian Springs in the early history of Augusta and Summerville. It was located on what is now Heard Avenue where Warren Street intersects Heard. Originally it was on property granted to Governor John Milledge. Later, it was part of a large tract of land in Summerville owned by Nancy Heckle. She left the portion of her land bounded by Telfair Street (Hickman Road), Battle Row, Eve Street, and Heckle Street to her son Thomas Heckle in 1864. He became the owner of the spring. Heckle lived just a few hundred yards west of the spring near the southeast corner of Telfair Street and Battle Row. It is possible that Thomas Heckle's family are the people visible on the gazebo. The site was later developed into Lankey's Bathing Pond. (Photographer: J.A. Palmer.)

This southern farmhouse is not identified by family name, but its number in the sequence of the stereo views taken in Summerville by J.A. Palmer indicates it could be Thomas Heckle's home. The general plan of the house conforms to the layout shown on the 1920 Sanborn Insurance Map. It also matches a description given to the author by the late Mrs. Lolita Stanford Born, who visited the home many times. This view is from the east side in the back yard looking to the west around 1875. It was located between Telfair Street (Hickman Road) and Heard Avenue near Battle Row, but is no longer standing.

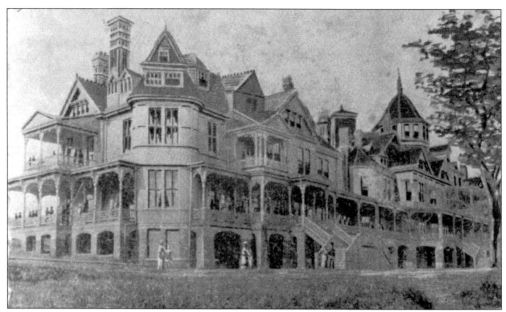

The Hotel Bon Air is shown here in 1891, two years after it was built. Most published photographs of the hotel are views subsequent to the many additions to the building. The hotel could accommodate 300 people. It had electric lights in every room. The large octagon-shaped solarium on top of the hotel in the center could be reached by use of the Otis electric elevator. (Hotel Bon Air Brochure, 1891.)

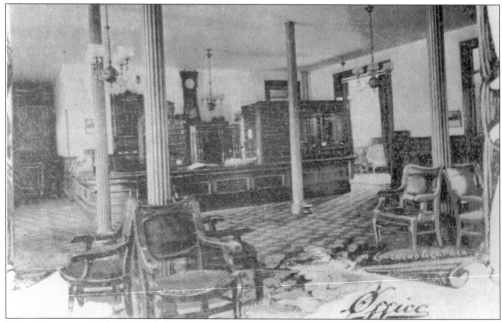

The office was on the second floor of the hotel and could be reached by the entrance from the verandah, which extended around the entire front and south side of the hotel. The office was large, well furnished, and carpeted. The woodwork was made of curled Georgia pine. Electric call bells were in every room. Mr. C.A. Linsley, an experienced hotel man, was the manager. (Hotel Bon Air Brochure, 1891.)

The ladies' and gentlemen's parlor and the ladies' writing room were both located off the office room on the second floor. These rooms were well furnished and carpeted. The parlor had large fireplaces at each end. It was furnished with antique oak pieces and upholstered and wicker chairs. (Hotel Bon Air Brochure, 1891.)

The large dining in the hotel could seat 300 people at one time. The floor and the ceiling were made of curled Georgia pine. The floor was so highly polished it looked like a mirror. The ceiling was 18 feet high with massive carved beams running across at intervals. The chef was Mr. Louis Fernandez, who was noted as "a classical culinary artist and his work is of the highest order." The china and the silver were specially ordered for the Hotel Bon Air. (Hotel Bon Air Brochure, 1891.)

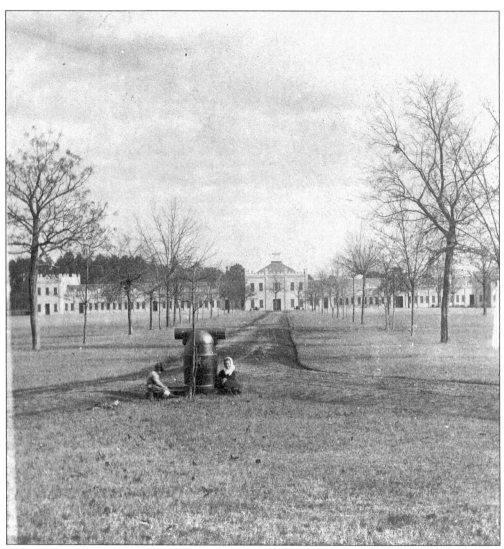

The Shop Building, as it is commonly called, at the Augusta Arsenal was built under the command of Lt. Col. W.G. Gill in 1861. General Gorgas, chief of ordnance of the Confederate Army, ordered its construction. This photograph was taken around 1870. The building ran parallel to what is now Katherine Street at the eastern end of the property. During the Civil War parts of the building were used at various times for a storehouse, blacksmith shop, tin shop, harness-making area, and a hospital for gangrene patients. Cartridges were also manufactured in the building. The building was used in World War I and World War II for overhauling small arms among numerous other functions. The arsenal was closed in 1955 and the building no longer exists. The property is now the site of Augusta State University. (Photographer: J.W. Perkins.)

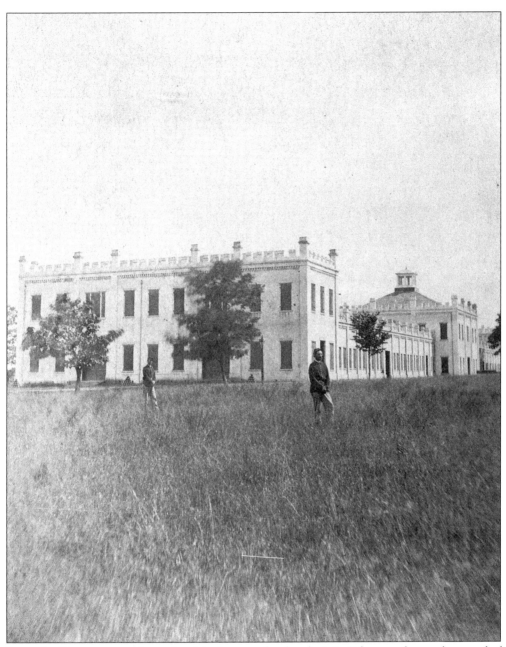

Several military personnel pose for this photograph taken by J.A. Palmer at the northern end of the Shop Building around 1880. The current Augusta State University Student Center is located approximately where the soldier at the left is standing.

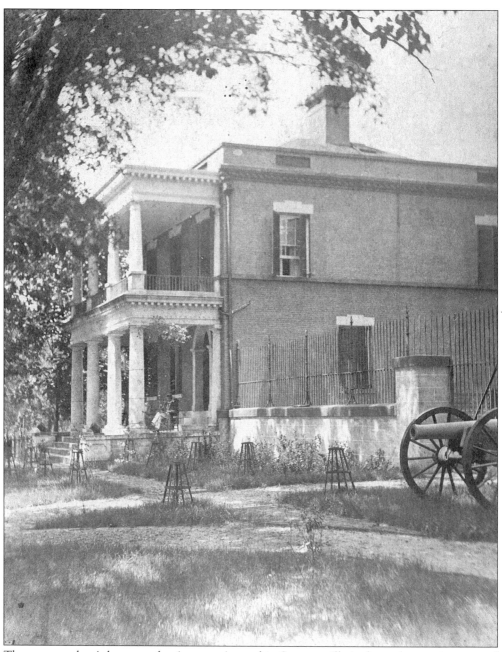

The commandant's house at the Augusta Arsenal in Summerville is shown here as it appeared around 1880. A man in civilian clothes sits in a chair on the front porch. There are two small mortars on each side of the steps. The basic appearance of the house has not changed but there have been additions to it over the years. The wall and the iron fence still exist. A two-story wing has been added where the window at upper right is located. A one-story enclosed piazza has been added under the upper left window. The front of the piazza room was built right on top of the existing wall where it intersects the house. (Photographer: J.A. Palmer.)

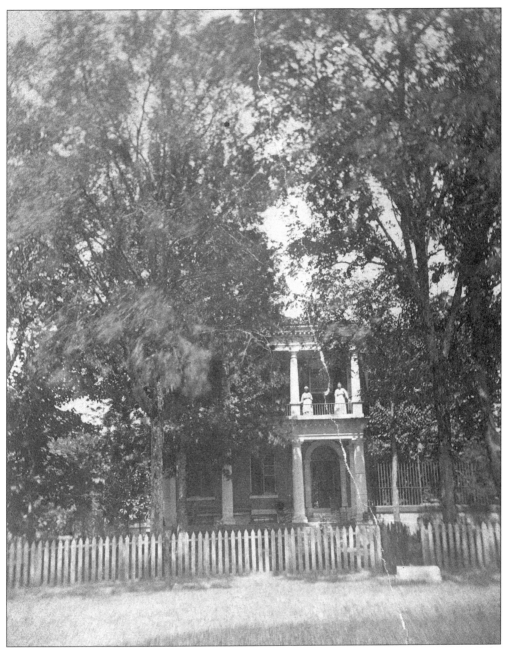

This front view of the commandant's house at the Augusta Arsenal shows the roadway and the large shade trees that were on the site around 1880. Two ladies stand at the railing on the upper porch watching the photographer, J.A. Palmer. The arsenal, which had been established near the river in 1819, was moved to Summerville in 1829 because of unhealthy conditions at the river site. The commandant's home, the adjacent headquarters building to the north, and the officers quarters are now part of the Augusta State University administrative complex. The commandant's home is now known as the Benet House.

INDEX

1888 Flood, 4, 21, 29-30, 98-99
403 Telfair Street, 72
Adam Family, 46
African-Americans, 37-39, 101-110
Augusta Arsenal, 124-127
Augusta Canal, 90-92
Augusta Factory, 93
Augusta Hotel, 9, 16
Augusta National Exposition, 80
Augusta Orphan Asylum, 57
Austin, Ann, 44
bell tower, 24, 51, 56
Bennett, Henry, 103
Berckmans, Lt. Robert C., 82
Berry, J.M., 98
Bethlehem School, 104-105
Bohler, Augustus R., 85
Boulineau family, 46
Bowe, R.J. 56
Brahe, F.A., 4, 18, 60, 75
Bredenburg family, 48
bridges, 96-97
Broad Street, 2, 4, 10-11, 13-15, 17, 20-22, 31, 33, 54
Cedar Grove Cemetery, 110
Central Grammar School, 79
Chain Gang, 101
Chronicle Building, 17, 18
Church of the Atonement, 70
Church of the Good Shepherd, 116
City Cemetery-Magnolia Cem., 44-50
Clanton, Turner, 74
Clayton, Edward P., 30
Cohen, John J., 16, 27
Coleman, Dr. John Scott, 81
Confederate Cenotaph, 26-27, 38-39
Confederate Monument, 17, 20, 34, 31-32
Confederate Powder Works, 52-53
Confederate Survivors Fair, 86
courthouse, 65
Cracker Cart, 67
Doolittle, Oliver P. & Samuel E., 59
Edgar, J.S., 119

Elliott, Reverend Stephen, 83
First Baptist Church, 71
First Presbyterian Church, 68-69
Fountain, Broad Street, 43
Fruitticher, Ed., 115
Gardner, Colonel James, 73
Gehrken, Dietrich, 60
Gehrken, Fred, 59
Georgia Railroad Cotton Yard, 95
Girl with poem, 85
Girl with puppy, 83
Globe Hotel, 19
Goodrich, William H., 57
Granite Mills, 64
Greek Revival house, 73-74
Greene Street, 51, 23-30, 37-39, 51
Hack, Josie, 84
haunted pillar, 12-13
Head, Anna Platt, 118
Heard, Richard W., 118
Heckle, George, 112-115
Heckle, Mary Louise, 114
Heckle, Sarah Atmar Rogers, 114
Heckle, Stella, 115
Heckle, Thomas, 120-121
Hookey, George S., 29
Hotel Bon Air, 111, 122-123
Houghton Grammar School, 88
Hull, Asbury, 27
Indian Springs, 120
Kahrs, N. & Co., 59
King Mill, 89
Lee & Bothwell, 99
Long, Helen, 84
Market, 12-13
Masonic Temple, 18, 54
May, Robert H., 18, 21, 40, 48, 110
May Park, 40-42
McCay, Eugene B., 47
Miller, Bissel & Burum, 16
Moore's Lagoon, 77
Mulberry Tree, 77
Osborne, Henry, 102
Owen, Winnie Mae, 79
Pasquet, Alphonse, 74

Pioneer Hook & Ladder No. 1, 24, 56, 78
Planters Hotel, 62
Platt Bros., 18, 61
Platt, Charles A., 61
Platt, Jacob B., 56
Platt, Katherine Douglas, 118
Platt, W. Edward, 56, 61
Platt, W.L., 27
Plumb & Leitner, 18
post office, 64
Rae's Creek, 80
railroad, 99-100
Rhodes, T.R., 45
Richers & Gehrken, 59
Richers, Christian, 59
Richmond Fire Co. No. 7, 78
Robbe, Charles A., 66
Robert H. May & Co., 18
Rogers, John R., 6
Rogers, Ralph I., 6
Rutherford, William J., 72
Sale, James B. Franklin, 100
Savannah River, 96-97
Schley Family, 76
Schneider, Ernest R., 58
Schweigert, William, 4, 60
Sibley Central School, 88
Sibley Mill, 89
Signers Monument, 25, 35-37
Southern Express Co., 16
State House of Georgia, 63
Steamboat *Rosa*, 96
Sturman Preparatory School, 86
Summerville, 111-123
Summerville Academy, 115
Telfair Street (Hickman Road), 117-119, 121
Tubman High School, 87
Union Depot, 99
Usher, John Jr., 18, 60
Verdery, J.P., 115
Volunteer Fire Dept., 15, 78
Washington Fire Company No. 1 (Hose), 24, 56
Water Tank, 55, 71, 95
Wheless & Company, 94